IMAGES
of America

GLENCOE

ILLINOIS

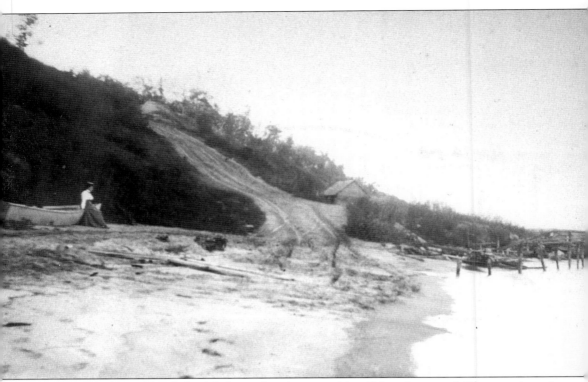

The shoreline along Lake Michigan has been an identifying feature of Glencoe since its founding when original settler Anson Taylor brought his belongings from Chicago. Early settlers sent lumber and charcoal back down the lake on rafts drawn by teams of oxen. Since the reversal of the Chicago River, the lakefront has been a desirable place for beautiful homes and summer recreation. This turn-of-the-century photo reads simply: "The Beach at Glencoe, Ills. (sic), and Edith."

Cover Image: The picture of the 1925 graduating class of Glencoe's Central School was taken outside of the old school building on Greenwood Avenue. Clara Dietz, science teacher extraordinare, known to both accompany her students on a myriad of outings to investigate the flora and fauna and to "eat bugs" to show how related humans and animals are, is fourth from the right in the second row down from the top. The Village's bird sanctuary is named in her honor.

IMAGES
of America

GLENCOE

ILLINOIS

Ellen Kettler Paseltiner and Ellen Shubart
For the Glencoe Historical Society

ARCADIA

First Printed 2002.
Reprinted 2003.

Published by Arcadia Publishing,
an imprint of Tempus Publishing, Inc.
3047 N. Lincoln Ave., Suite 410
Chicago, IL 60657

Printed in Great Britain.

Library of Congress Catalog Card Number: 2002108561

For all general information contact Arcadia Publishing at:
Telephone 843-853-2070
Fax 843-853-0044
E-Mail sales@arcadiapublishing.com

For customer service and orders:
Toll-Free 1-888-313-2665

Visit us on the internet at http://www.arcadiapublishing.com

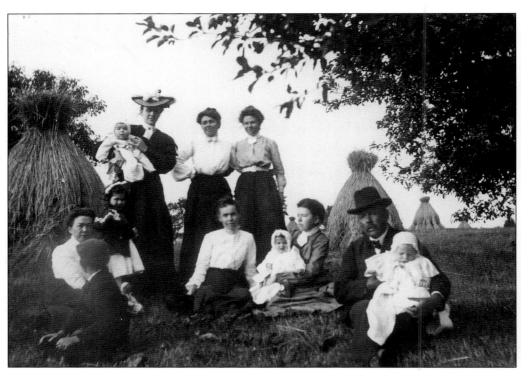

The Diettrich family gathered in the apple orchard on the family farm where the Skokie Heights subdivision is located today. Veit Diettrich, a matchmaker by trade, had come to the Chicago area in 1839. The farm's orchard was at Green Bay Road and the entrance to Skokie Heights. The photo was taken c. 1900.

CONTENTS

ACKNOWLEDGMENTS

We would like to profusely thank the following people:

- Barb Olinger, Elizabeth Hopper, Dan Goodwin, and Beth Berry, a formidable team that met weekly during this year to set up the new Research Center for the Glencoe Historical Society at the Eklund History Center and Garden. With their help, we uncovered many of the photographs and documents used for this book.
- Marianne Crosby, Wilson Rankin, Roland Calhoun, Wally Peterson, and Bob Morris for their comments, identifications, and reminiscences about the photographs.
- Scott Javore for his slides and histories of Glencoe and the North Shore.
- Susan Myrick for her architectural photography done for the Historical Society's Architectural Survey, 1985–1990.
- Rod Aiken, Director of the Glencoe Park District; Cathlene Crawford, Superintendent of the Glencoe Schools; Peggy Hamil, Director of the Glencoe Public Library; Peter Scalera, Assistant to the Village Manager; and Paul Harlow, Village Manager, for their help in obtaining photographs for this book.
- Susan Bisgeier, Barb Achenbaum, Catherine Wang, Andy Millman, Melissa Landsman, Alice Hanig, and Carol Dawley for providing photographs for the Village Life section.
- Alice Glicksberg for helping to do the final layout and Richard Shubart for his reading and editing of the text.
- Scott Paseltiner for his support and editorial comments.
- Harris Paseltiner for his computer help and photographic suggestions.
- *Pioneer Press* (*Glencoe News*) for permission to use pictures from past years. Their able photographers have documented much of Glencoe's history.
- Finally, the Glencoe Historical Society Board for their support, enthusiasm, and input on the book at the various stages of compilation.

Their contributions enriched this book. Any mistakes are ours alone.

INTRODUCTION

Dr. Alexander Hammond, whose 1869 Glencoe only counted 150 persons, would not recognize Glencoe as it enters the 21st century, with nearly 9,000 residents. But his vision remains. When the Rockford physician purchased a farm in the center of what is now Glencoe, he brought his family to a physically lush and beautiful area where he planned to build a utopia, an ideal village. Although Dr. Hammond did not stay long enough to see the village grow, as we look back, we realize his dream has come true.

Glencoe today still features spacious and lovely homes amid canopies of trees. The park overlooking the beach still is set aside for everyone's enjoyment, and the schools are rated among the best not only in the region, but also the nation. The 2000 census tells us this is a community of families. Close to 2,400 married-couple families with children less than 18 years of age live in this community of 3,072 total households. Glencoe's median family income and median home value rank high, both in the region and the nation.

Glencoe residents pride themselves on their contributions to not only their own village, but to Chicago and the nation. From the beginning, when Civil War General Charles Howard moved to Greenleaf Avenue, to the time when Archibald MacLeish became the nation's poet laureate, or to when Melville Stone established the *Chicago Daily News*, those who called Glencoe home were aware of their duty to serve others. They showed their civic pride by participating in good government, and their innovations served as a model for others. Glencoe's village-manager form of government was established in 1914, the first in Illinois. The Village was first in the state to combine police and firemen into one Department of Public Safety. Its school and park boards were the originators of the parks-by-schools/schools-in-parks plan. The first Boy Scout troop west of the Alleghenies began in Glencoe, and the third women's club in Illinois still makes its home on Tudor Court.

Frank Lloyd Wright did some of his earliest Prairie-style homes here, leaving a legacy of the third-largest collection of Wright homes outside of Oak Park and Chicago. Other noted architects also left their marks: Howard van Doren Shaw, David Adler, George Fred and William Keck, and George W. Maher. Today the streets of Glencoe are lined with some homes that date to Dr. Hammond's time, including the magnificent Castle, his own home, but also with others that came later. It shines with buildings from a diverse amalgam of styles and times—Victorian painted ladies, Colonial and Tudor revivals, often side-by-side with Modern homes.

But it is the people who make a community vibrant. From its German farmer beginnings, Glencoe has opened its arms to people from all walks of life—farmers and tradesmen who worked in the vicinity of Park and Vernon Avenues, or lawyers and corporate executives who commuted to the city for their jobs. Glencoe, whose business core began with a stagecoach stop and a pier to ship lumber to the fast-growing city to the south, has evolved to become a center of boutique shopping and coffeehouses. It is a village of diversity that expanded from Dr. Hammond's single church to encompass a variety of houses of worship, ranging from the Methodist and Episcopal to the North Shore's first Reform Jewish congregation, the Baha'i, and

Korean Presbyterian. Glencoe is home to the only African Methodist Episcopal Church between Evanston and Lake Forest, having welcomed African Americans to the community almost immediately after the Village's 1869 incorporation.

Throughout Glencoe's history, family-oriented activities have been central, including lazy days at the beach, games in Kalk Park on Pumpkin Day, parades and picnics for the Fourth of July, the Village's Centennial celebration, and the passing of the Olympic torch in 2002. Glencoe is tied up in Boy and Girl Scout neckerchiefs, rings with the voices in church choirs, prays at the Village's ecumenical Thanksgiving service, and sparkles with the holiday lights that encircle the trees in the business district from November through January. Its history has been recorded since the turn of the past century in, among others, the *Glencoe Reminder*, the *Glenettka Window*, and today's *Glencoe News*, as well as volumes from the Glencoe Historical Society and throughout the national media.

This book came about quickly, through the request for the Glencoe Historical Society to create a picture-history of the Village. Having just arrived in its new home, the Eklund History Center and Garden, the Society's collection was in boxes, packed away after a move from Watts Center. But in a short time—five months—the authors uncovered enough photos, did a great deal of research, and wrote the accompanying chapter introductions and captions. Each Ellen packed up and sold a house during this time. Ellen Kettler Paseltiner set up the Eklund Center Research Library. Ellen Shubart attended meetings of the Glencoe Historic Preservation and Plan Commissions. The book was completed with time snatched from families, from moving, and from jobs.

Ellen Kettler Paseltiner, an attorney who formerly worked with the National Trust for Historic Preservation, is a 20-year resident of Glencoe. She is Research Center Director of the Glencoe Historical Society. She was instrumental in peeling back the history of the Village like an onion, getting to the center of each issue, and checking the accuracy of the text. As she opened box after box, pictures were retrieved and scrapbooks read to find data and dates. Ellen Shubart, who has lived in Glencoe since 1972, is President of the society. The two are on a hard-working board that is forwarding the mission of the Society begun in the 1930s: to collect and preserve data—books, photographs, artifacts and maps—concerning the history of the Village, and to help the public learn about Glencoe from its new home, a spacious former barn and glorious garden.

One of Glencoe's oldest documents, Gormley's Map of Glencoe, dubbed the Village "Queen of Suburbs." In "Glencoe Lights 100 Candles," the Village's Centennial commemoration book, Glencoe was described as an "America in microcosm … (an) imperfect paradise." Those hold true today. Dr. Hammond's vision appears to have been more than met. And the two Ellens are delighted to present this photographic history as a vision of how that was accomplished.

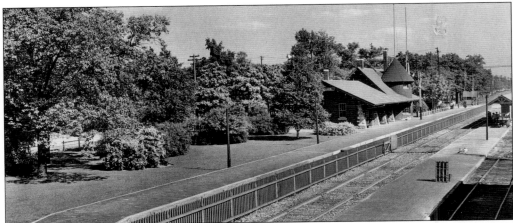

A 1915 aerial view of the Glencoe Train Station, a Village landmark since it was built in 1891.

One

EARLY GLENCOE

"QUEEN OF SUBURBS"

The Native Americans were here first; they walked softly and left arrowheads to remind us of their presence. They hunted the wild game in the heavily wooded ravines and fished in Lake Michigan and the Skokie marsh, but lived on the flatter lands to the west and south.

In 1835, when Chicago was barely two years old and had a population of less than 500, Anson Taylor, a young storekeeper, builder, and trader, came north along the lake shore. On a bluff overlooking the lake in the area of what is now southeast Glencoe, Taylor built a log cabin, establishing himself as Glencoe's first white settler. He built a two-story frame building with a small store and post office that served as an inn for nearly half a century. The LaPier House welcomed stagecoaches traveling between Chicago and Green Bay, Wisconsin. The area was known as Taylorsport until the Civil War. Others moved to the area beginning in the late 1830s. Land became available for settlement after a treaty with Native Americans. These settlers, many of German and English origin, established farms and homesteads to the north and west of Taylorsport.

The nature and name of the settlement changed in the mid-1850s. Walter Gurnee, twice mayor of Chicago and president of the Chicago and Milwaukee Railroad, purchased a large stock farm in the area that belonged to his father-in-law, Matthew Coe. Gurnee moved into the house on the property, and when the railroad came through in 1855, a station was built opposite president Gurnee's home. The future Village of Glencoe began to grow around this nucleus of the railroad station. The origin of the name Glencoe comes from this early time. Some hold that because of the village's ravines (glens) and in honor of his wife's maiden name, Coe, Gurnee named the village Coe's Glen, or Glencoe. Others believe it was named for his ancestral home, Glencoe, Scotland. The original village seal and an early library bookplate both carried the emblem of the Scottish town.

The last major player who helped to mold the future of the village was Dr. Alexander Hammond, who bought Gurnee's home and land in 1867. Hammond had a vision of a utopian village, as a map of the era called, "Glencoe: Queen of Suburbs." He enlisted nine other men to form the Glencoe Company. Each member promised to help subsidize a community church, pay annually for a pastor, a school, and a teacher, and build one house for himself plus a second to sell in order to spur development. The foot of Park Avenue along the lakefront was set aside in perpetuity for use as a park. The Village was incorporated March 29, 1869.

Anson Taylor was an early resident of Chicago and a storekeeper, builder, and trader. He and his brother Charles built the first bridge across the Chicago River connecting the south bank with the Green Bay Trail leading north. In 1835, Taylor and his family made their way along Lake Michigan to a bluff and settled just north of the large ravines in southeast Glencoe, becoming the area's first white settler. The area became known as Taylorsport.

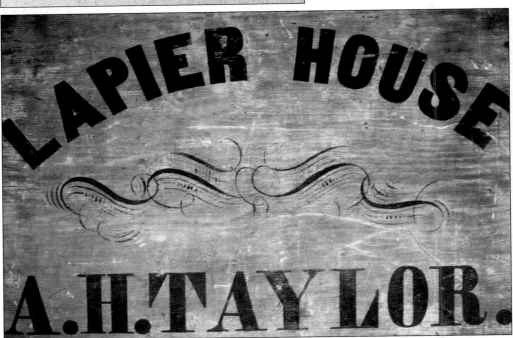

This old wooden sign hung outside early settler Anson Taylor's establishment, LaPier House on the Green Bay Trail, welcoming travelers who were one night out from Chicago. The two-story frame building was located at what is now 185 Old Green Bay Road. The hospitable inn stood for nearly half a century, from the 1840s until the 1890s.

This is a scene depicting a family gathering at the home of Dr. Alexander Hammond, founder of Glencoe, around 1871. The house was originally built for Matthew Coe and later his son-in-law, Walter Gurnee, who purchased Coe's 520-acre stock farm. Hammond's daughter Sarah is the girl seated in the middle of the three-girl grouping. The pendant white trim on the eaves of the house is an interesting feature.

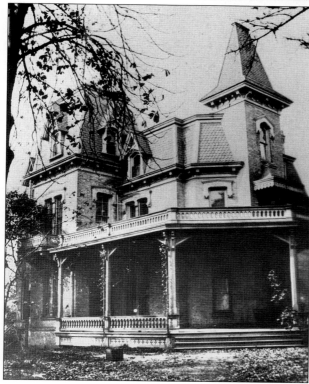

The home now known locally as "The Castle" belonged originally to Walter Gurnee and then to Glencoe founder Dr. Alexander Hammond. Its next owner, George Ligare, remodeled the house in the 1870s. Ligare at one time operated a large lumberyard on the site of the Merchandise Mart in Chicago. He named his Glencoe home Maple Lodge, as the grounds contained many beautiful tree specimens. Ligare was later president of the Village.

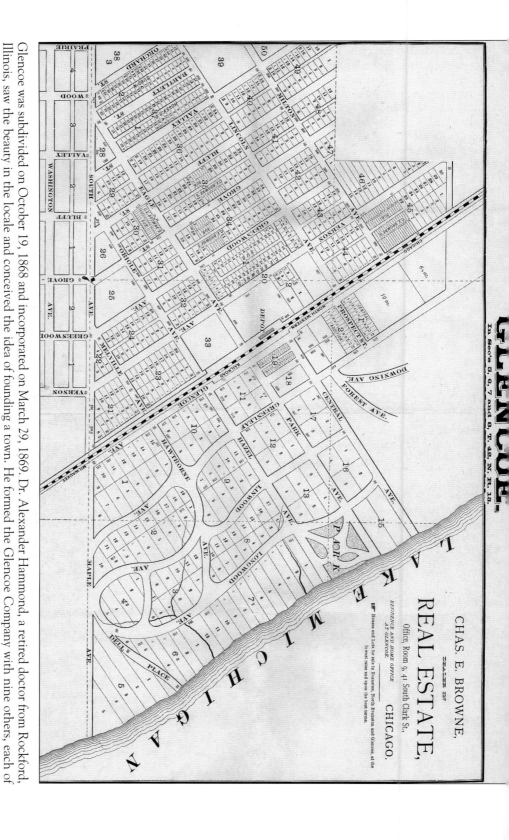

Glencoe was subdivided on October 19, 1868 and incorporated on March 29, 1869. Dr. Alexander Hammond, a retired doctor from Rockford, Illinois, saw the beauty in the locale and conceived the idea of founding a town. He formed the Glencoe Company with nine others, each of whom would pay $5,000 plus $500 for a church and school, pastor, teacher, roads, and shrubbery. The map shows the original street layout. According to legend, men named the streets east of the tracks and women named the streets on the west.

12

Charles Browne was in the real estate business in Evanston. He was one of the original ten members of the Glencoe Company that formed Glencoe under the leadership of Dr. Alexander Hammond in 1869. He was later president of the Village.

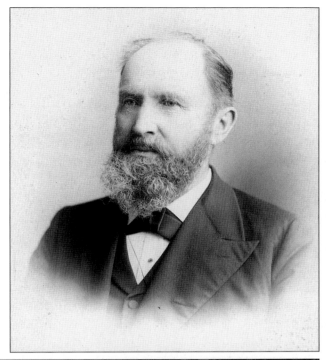

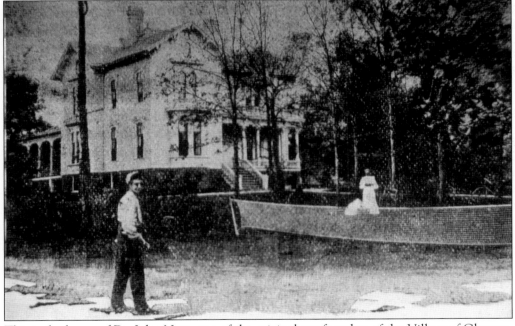

This is the home of Dr. John Nutt, one of the original ten founders of the Village of Glencoe. Dr. Nutt shared Dr. Alexander Hammond's vision and built two homes on Hazel Avenue at Sheridan Road, one for his family and one to sell. His wife was the sister of John Evans, for whom Evanston is named. She was also the first president of the Woman's Library Club. Their son John was the first child born in incorporated Glencoe.

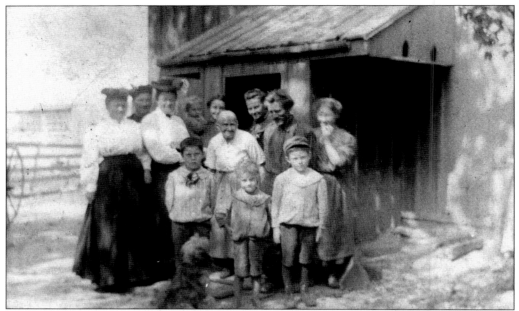

Early German farm settlers included the August Beinlich family, arriving in Glencoe about 1855. After residing in Chicago for a few years, the Beinlichs moved to the Glencoe area and settled on a 20-acre tract west of the railroad tracks adjacent to the Veit Diettrich homestead. The Beinlichs also settled west along Dundee Road, purchasing land at $1.25 an acre. At one time their homestead comprised sixty acres.

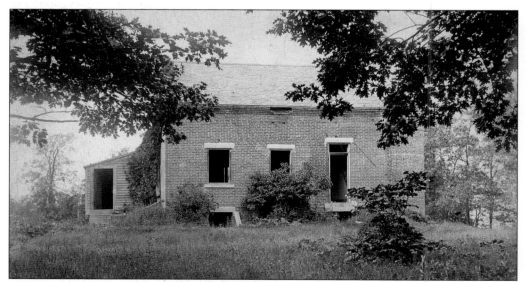

In 1864, the U.S. government established a lighthouse on two acres of land donated by Anson Taylor at the northeast corner of Harbor Street and Sheridan Road. Taylor's son, Louis, was appointed lighthouse keeper. When Louis later moved to Denver, his siblings Henry and Maria lived at the lighthouse and assumed Louis' job. No federal funds were appropriated for the maintenance of the lighthouse, so it never functioned properly. The ruins, above, were still standing in 1900.

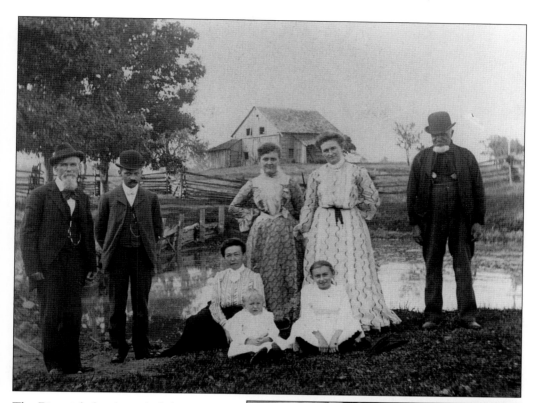

The Diettrich family included some of the earliest settlers in the Glencoe area. Veit Diettrich was the first maker of matches in Chicago in the 1830s. In 1839, he moved north and bought an eighty-acre farm in the vicinity of Vernon Avenue and Green Bay Road. This photograph is of the family at the home c.1898.

Franklin Newhall and his brother Frederick were early settlers to the new Village of Glencoe. A prosperous apple merchant, Franklin acquired property and built his home in northeast Glencoe in 1869. The house still stands today, at the southeast corner of Greenleaf and Beach. "Newhall Woods" extended northward from Beach Road and became one of Glencoe's most favorable properties. In his later years, Franklin, right, became known as Grandpa Newhall to the Village's children.

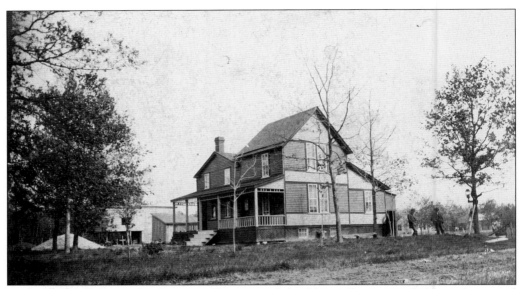

Michael Gormley was the Secretary-Treasurer of the Union Engraving, Lithographing, and Steam Printing Company in Chicago. He made the first engraved map of Glencoe, before his plant was destroyed in the Great Chicago Fire of 1871. Known locally as Squire Gormley, his farm (house above) was at the corner of South Avenue and Grove Street. Part of his farm became the Skokie Country Club golf course.

The Turnbulls were English farmers who settled on the land west of another English family, the Daggitts, in northeast Glencoe. The property is today's Turnbull Woods, part of the Cook County Forest Preserve District, and the Glencoe Golf Club. The Turnbulls helped establish the first school in Glencoe. Pictured left is William J. Turnbull.

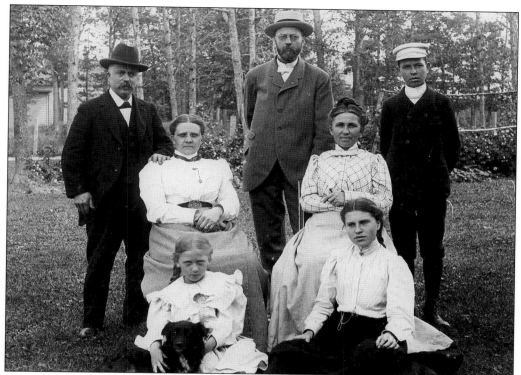

Above is a family portrait of the DeLang family in the 1890s, on the south lawn of their home at Trail Tree, on the lake along Longwood Avenue. Pictured here, from left to right, are as follows: (top row) Andrew Larson, Frederick DeLang, Blanchard DeLang; (middle row) Marie Larson and Serene DeLang; and (bottom row) Ethel DeLang (later Hein) with Rover and Jessie DeLang.

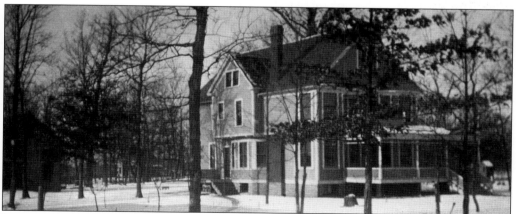

James Kent Calhoun and Alice Browne Calhoun built this Victorian home in 1894 on the west side of Greenwood Avenue. Alice was the daughter of Charles Browne, one of the ten original Glencoe Company founders. The side door accommodated those persons alighting from carriages as they made their way to the barn at the rear of the property. Both James Calhoun and his son Roland served Glencoe as Village President. Grandson Scott Javore and his family now live in the house.

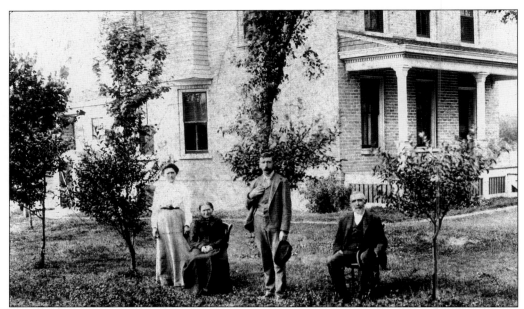

The Behrens home stood where the Glencoe Golf Club is today. Jacob Behrens, seated, was born in 1831 and died in 1904. He and his wife Margaretta, also seated, were members of the Trinity Lutheran Church in Glencoe. Rose and Henry Behrens are standing. Jacob and Margaretta Behrens are buried in the Daggitt Cemetery on Lake Cook Road that was restored and rededicated in 1996.

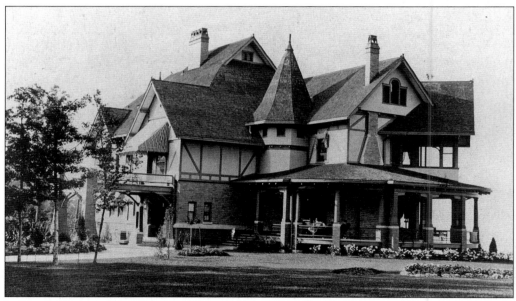

Indianola, home of the Hermann Paepcke family, was built in 1902 on 20 acres of lakefront property at Sheridan and Franklin Roads. Hermann Paepcke was a lumber baron. His son Walter was the founder of the Chicago-based Container Corporation, one of the nation's largest packaging firms. Walter and Elizabeth "Pussy" Paepcke established the Aspen Music Festival and Institute in Aspen, Colorado. The house no longer stands.

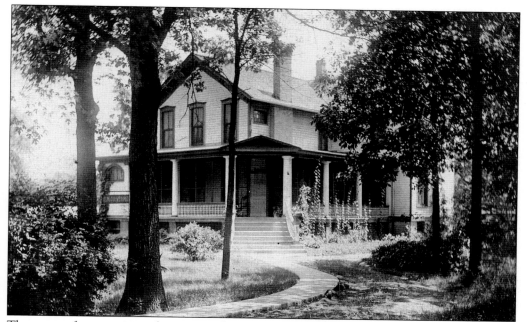

There were few practicing doctors in Glencoe during the latter half of the 19th century. One of the first doctors to reside in the Village was a woman, Dr. Eugenia Culver. Her home, known as Dr. Culver's Hospital, still stands on Washington Avenue, above.

Farming was the major occupation in the earliest days of Glencoe. Cows, such as this one seen on Drexel Avenue, were almost as numerous as settlers. In 1905, Dr. Alexander Hammond reminisced about the evergreens totalling over 1,000 that the Glencoe Company planted after its 1869 incorporation. He noted, however, that the population "allowed the cattle to run at large and hook (the trees) to pieces and destroy them, so there was not much left to show for it."

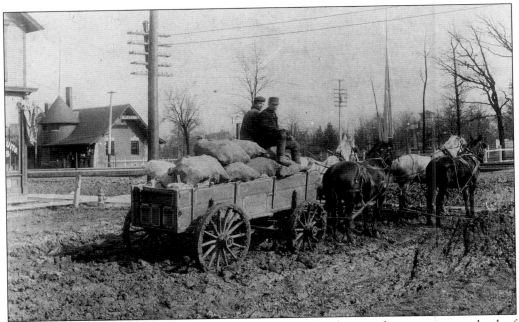

Henry Berning Sr. and his son, Henry Jr., of Northbrook are taking a one-ton load of horseradish to market in 1906. Because of the muddy streets, it required a four-horse team to get through. The Glencoe train station, built in 1891, is in the background. Brick pavements in the business district did not become the norm until 1914.

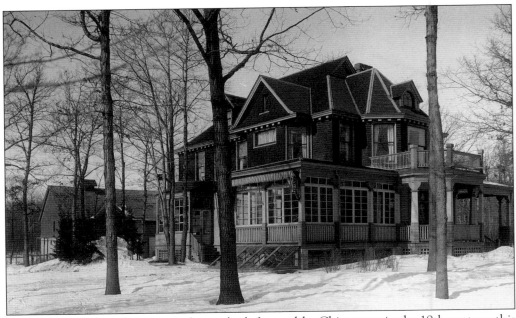

Reminiscent of the other summer homes built for wealthy Chicagoans in the 19th century, this home was built in 1893 as a summer escape. It was sold to the Hotz family in 1895. The Hotzes were internationally-famous custom jewelers and many famous people visited the home over the years. Here, two family members enjoy the snowy day.

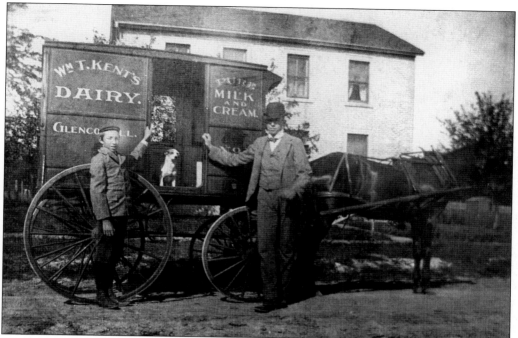

There were several dairies in Glencoe. Milk was delivered by horse-drawn wagon. The horses came to know the route almost as well as the driver, and would stop without orders at each house. James Kent, shown here at right, became the resident mover for the Village. His headquarters were in a storage room next to Johnson's Garage on Vernon Avenue.

"Hubbard's Hill," named for Gilbert Hubbard, was the steep road leading down into the ravines just south of Scott Avenue on the Winnetka-Glencoe border. The ravines are the first deep ravines north of Chicago. Gilbert Hubbard was an early settler in the area and owner of extensive acreage in the northeast section of Winnetka in 1854. The area of Hubbard Woods, on Glencoe's southern border, is also named for Hubbard.

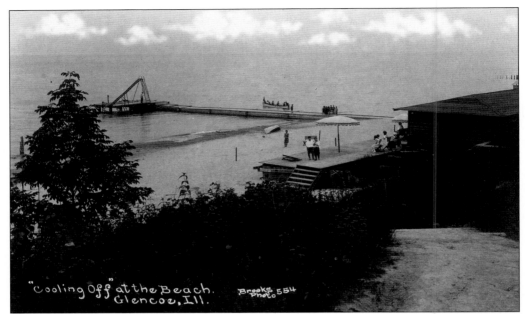

"Cooling Off" at the Beach. Glencoe, Ill. Brooks Photo 554

Before the present bath house at the beach was built in 1928, a frame structure served the Glencoe community. Here, the wooden beach house is visible as is the narrow depth of the beach prior to the sand buildup along the north side of the pier. A slide is at the end of the pier.

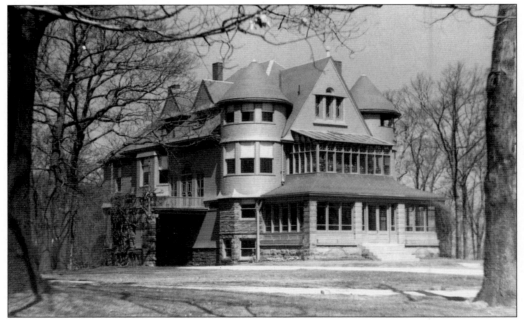

Completed in 1891, Craigie Lea was the home of the Andrew MacLeish family. MacLeish headed the retail department store Carson Pirie Scott and Company, and his wife Martha served as president of Rockford College. Their son Archibald, who grew up in Glencoe, was a Pulitzer Prize-winning poet and Librarian of Congress. Glencoe architect John Flanders designed the home that was situated on a bluff overlooking Lake Michigan near Dell Place.

Two
BUSINESS DISTRICT

FROM BLACKSMITHS AND MEAT MARKETS
TO BOUTIQUES AND COFFEE SHOPS

Uptown or downtown? For many, Glencoe's business center is "uptown," to distinguish it from downtown Chicago. For others, it is "downtown," meaning where business is done. But no matter, it is the Village's business center, begun in the 1880s when shops were located along Park and Vernon Avenues. The commercial hub began with blacksmiths and feed stores.

In earlier times, industrial businesses also stretched along the south end of Green Bay Road (then called Glencoe Road) until they were removed by modern zoning. Eliminated from residential areas in the years before the Second World War were lumberyards, coal yards, and service stations. Food and candy stores, florists, and landscapers located in the southern residential end of the Village, too, until the 1950s and 1960s, when they were converted into homes or torn down.

Most of the buildings downtown are typical of the two-part commercial architecture that prevailed in the nation through the 1950s, with lower levels for public spaces—retail mostly—and upper floors used for residences or offices. Times changed. Clapboard buildings gave way to masonry and brick. Businesses changed. Banks came in the 1910s and 1920s, but left after the Depression to be replaced by other banks. The southeast corner of Park and Vernon, as an example of only one location, has been home to a general retail store, an ice cream parlor, the Citizen's National Bank, a stationery shop, a wallpaper store, and today is a coffeehouse. There have been losses: Bartoli's candy and ice cream shop, the Glencoe Theater, Christophe's dime store. There have been additions: An ordinance to permit liquor by the glass in 1975 brought new restaurants, the first of which was the Village Smithy on the south side of Park Avenue, west of Vernon Avenue. Originally housed in an old smithy, it was razed and replaced by a larger restaurant that morphed into a day spa by 2002. Even Wienecke's, built in 1902, where you could buy toys, tools, or towels, and give the clerk your name expecting to be billed, closed in 1993. Doing business changed, too. Where shopkeepers once locked up on Wednesday afternoons, today some are open on Sundays and evenings. Parking went from free and unlimited to metered and now free but limited. Throughout, however, parking has always been a topic of discussion—and a problem.

No matter what it is called, it's always been "town" for Glencoe residents—the place to gather, visit, and shop.

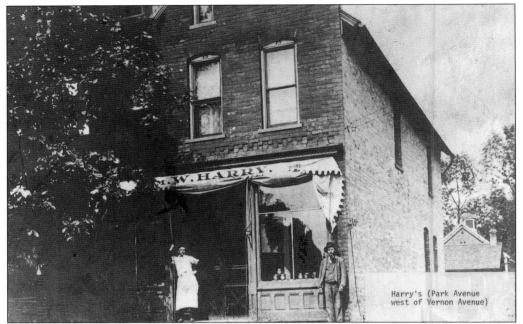

Harry's (Park Avenue west of Vernon Avenue)

The shop of M.W. Harry, called Harry's, was along the north side of Park Avenue west of Vernon Avenue. The brick two-story building, though no longer standing, had interesting decorative trim. The building in the rear appears to be home to a horse and carriage. Who the two men are is unknown, as is what Harry's sold. It is possible this is the same Harry for whom the Harry Hotel, also known as the Glencoe Hotel (later Glen Gables), on the south side of Park Avenue was named. The photo is from *c.* 1905.

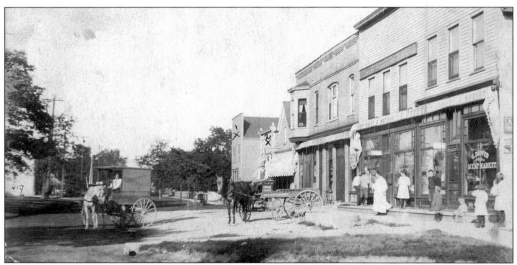

A late 1890s postcard shows the south side of Park Avenue looking east from Vernon Avenue. On the right is C. Dopfer's Meat Market, with Gents Furnishings Goods on the second floor. H.C. Schroeder Groceries and Market is to the east. The writer of the card put a 2X on his brother's shop and a "1X where we are going to move in about two or three weeks." The unsigned card is written to "Jesse."

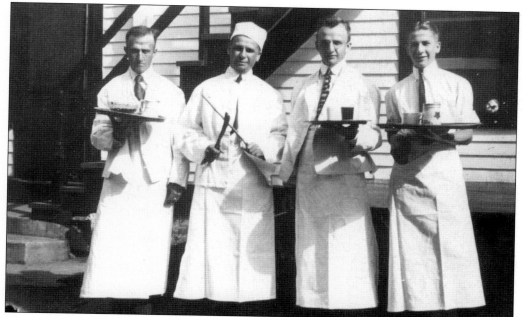

The four sons of Ignatz Schweiger (1859–1921) stand in front of the family restaurant at 367 Park Avenue, on the north side of the street, west of Vernon Avenue. Pictured here, from left to right, are: Ignatz, 1889–1964; Aloicius, 1888–1953; Sylvester, 1901–1980; and Frederick, 1905–1962. The elder Schweiger also built and owned the butcher shop next door at 375 Park Avenue, a building that doubled as the family quarters until it was sold in 1901. The photo is c. 1921.

Three-seventy-five Park Avenue (on the north side) began as a butcher shop. In 1917, Carl Eklund, a Swedish furniture maker and upholsterer, purchased it and lived with his family on the second floor. Eklund's son, Carl Hilding Eklund, and his daughter, Sara, both joined the business, which operated from the workshop behind this building. Sara Eklund deeded the grounds and workshop to the Glencoe Historical Society, which in 2001 opened the Eklund History Center and Garden, 377 Park Avenue. The photo is c. 1980s.

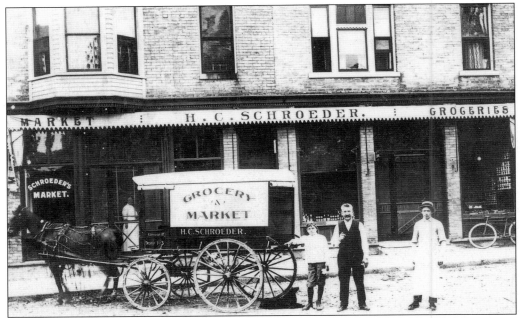

Along the south side of Park Avenue east of Vernon Avenue at the turn of the century, butchers stand in front of the wooden sidewalk at H.C. Schroeder Market and Groceries. Like many early settlers in the Village, the Schroeders were most likely immigrants from Germany. The picture is *c.* 1910–1920.

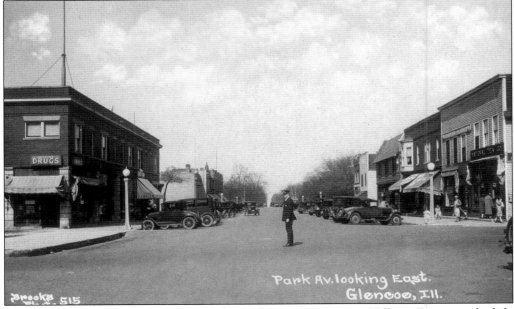

A police officer stands ready to direct traffic in this *c.* 1920s picture. Hillman Drugs, on the left, at the northeast corner of Park and Vernon Avenues, was the precursor of Hillman-Rehn's, then Rehn's Drugs, and today's Parkway Drugs. The National Tea Company, a grocery store, was next door.

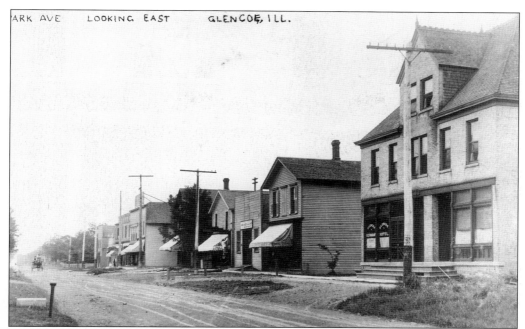

The south side of Park Avenue looking east to Vernon Avenue, *c.* mid-1890s, was unpaved and had sidewalks made of planks. Pictured at right is the Glencoe Hotel, beside it is Ralph Noble's Cigar Store building, and behind the tree is a blacksmith's shop. All but the hotel have disappeared, replaced by masonry structures.

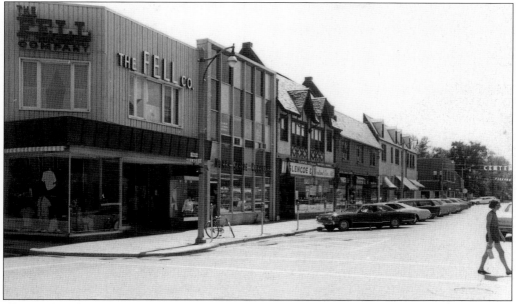

The south side of Park Avenue, looking west in 1969, shows The Fell Co. on the corner at Village Court. Fell's had moved from the other end of the block; the North Shore Cleaners put up its turquoise and cream front in the 1950s and the Glencoe Market was where Foodstuffs is today.

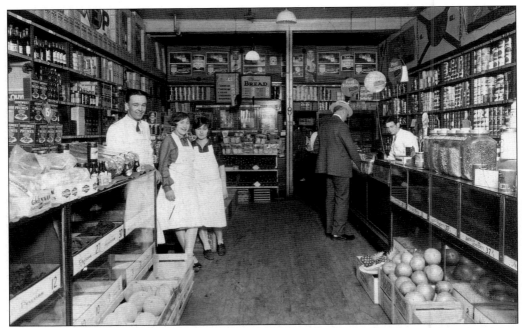

National Tea Company employees stand beside their produce bins. The picture is undated, but is most likely from the 1920s. National had two locations over the years: on the north side of Park Avenue just east of the Vernon Avenue intersection (where Starbucks is now), and where DeeJay's is today.

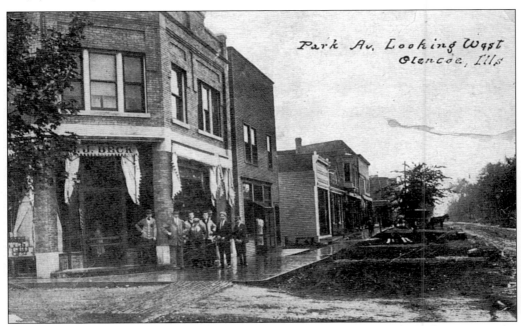

Above is a view of Park Avenue, looking west from Vernon Avenue, which shows J.J. Beck's and a number of men in front. This postcard is undated but is likely from the early 1900s. Today, the brick building is the location of the North Shore Community Bank.

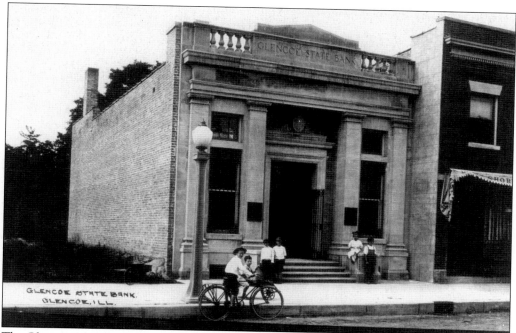

The Glencoe State Bank was located on the north side of Park Avenue, midway between Railroad Avenue (Green Bay Road) and Vernon Avenue, and is pictured *c.* 1920s. The Glencoe State Bank went bankrupt during the Great Depression and was reorganized as a national bank after the Second World War.

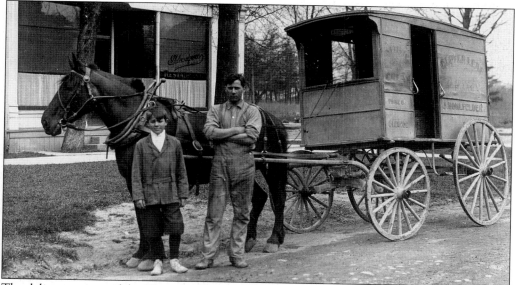

The delivery wagon of the Cloverleaf Dairy, owned by J. Hohlfelder, was photographed on Park Avenue, west of Vernon Avenue, in 1914. George Hohlfelder stands with his arms folded; Bill Schroeder stands next to him. Dairies were common in the Village, with dairy farms located in the northwest area through the Second World War. In addition to Cloverleaf, there was Hohlfelder Dairy, operated by the same family, and the William Kent Dairy.

This is a panoramic view of the north side of Park Avenue from Green Bay Road to the bank. The Jewel food store was the company's first "fixed" store, having begun business as a delivery

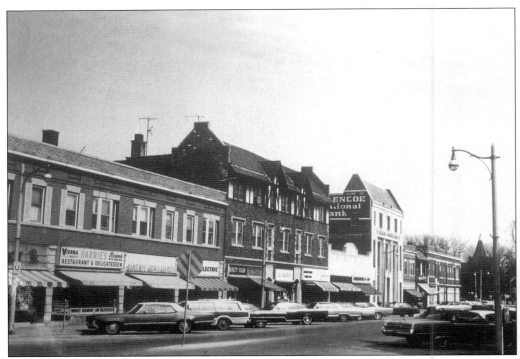

The north side of Park Avenue looking east from Vernon Avenue is pictured in the late 1960s. The building for the Glencoe National Bank, an Art Deco gem, was designed by noted architect Leon Stanhope. Christophe's, the five-and-dime store immediately west of the bank, was razed in the 1970s to create the bank's drive-through window. In the 1930s, the space had been filled with an A&P food store.

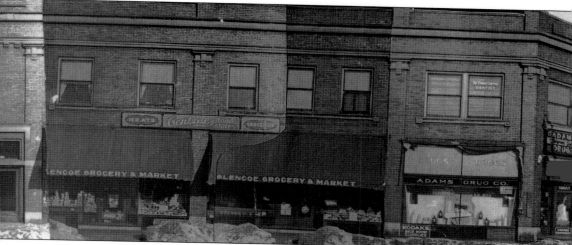

service. Adams Drug Co. and the Glencoe Grocery and Market were located in the Railroad or Zeising Building. This photo is from the 1940s.

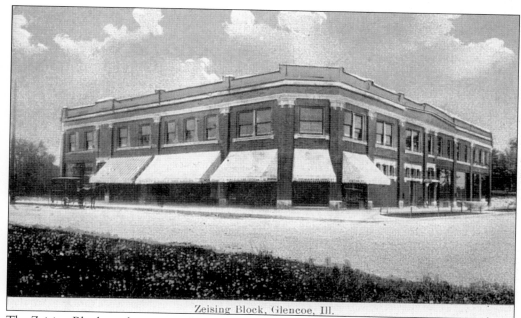

Zeising Block, Glencoe, Ill.

The Zeising Block, at the corner of Green Bay Road and Vernon Avenue is shown in a postcard drawing not long after it was built in 1909. At that time, the building was located on Railroad Avenue and named after its investor, August Zeising, president of American Bridge Company and a Glencoe resident. In the 1930s, the Glencoe post office was located in space on the east side of this building.

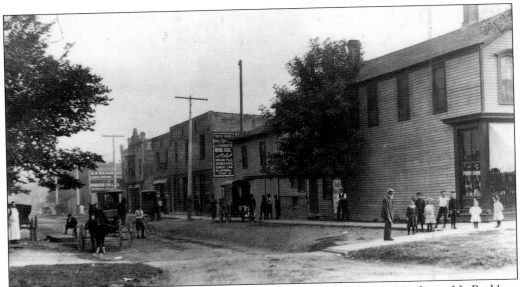

This image of Vernon Avenue, looking south from Park Avenue c. 1890, shows J.J. Beck's, a clapboard building where provisions and groceries were sold. It was later replaced with a brick building. The sidewalks were made of planks and the street was not yet paved. Signs on the buildings advertise lumber, wood, and coal, which were early products of Glencoe and necessities for those building and living in houses in the village of 569 people. Black stockings and dresses for the girls and knickers for the boys were the accepted attire at the time.

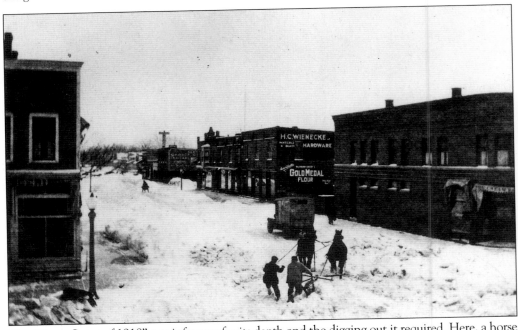

The "Great Snow of 1918" was infamous for its depth and the digging out it required. Here, a horse team works behind a car. Visible along the west side of Vernon Avenue is Bartoli and Peroni (called Bartoli's) ice cream shop at the corner of Park Avenue; Wienecke's, established in 1902, and its famous "Hardware" sign; and a garage farther south at what is now the 666 Vernon Plaza.

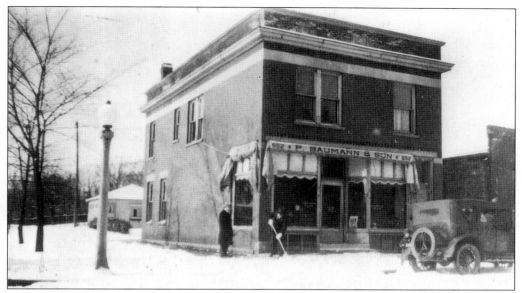

P. Baumann & Son Shoe Store, 652 Vernon Avenue, was at the northwest corner of Vernon and Hazel Avenues, where a dental office is located today. The c. 1920s photo shows the display windows on the first floor and residence(s) on the second, a typical commercial architectural style for the village's business district.

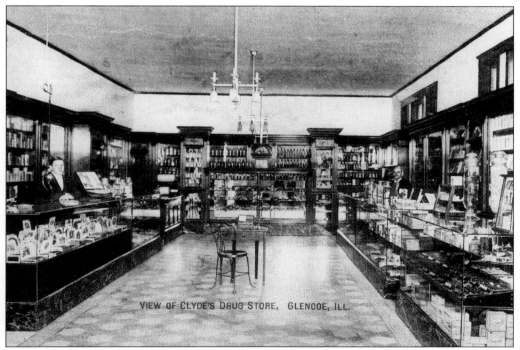

VIEW OF CLYDE'S DRUG STORE, GLENCOE, ILL.

Clyde's Drug Store, located on Vernon Avenue, was the epitome of a modern drug store in the 1920s. The cigar case on the left was prominent. The clerks are unidentified, although one might be Albert Clyde, proprietor.

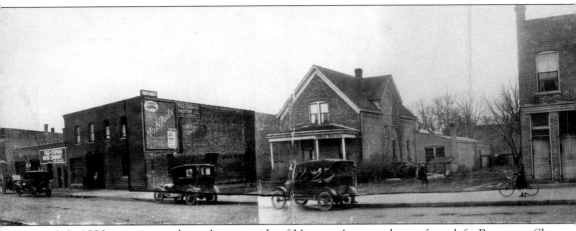

A c. 1920s panorama along the west side of Vernon Avenue shows, from left, Baumann Shoe Company, Page-Chapman Motor Company, Public Taxi Company, a cleaning and dyeing establishment, a barber shop, Henry C. Wienecke Hardware, and, across the alley, Bartoli's candy and ice cream shop. The last occupant of the auto sales space was Bill Madison Motors,

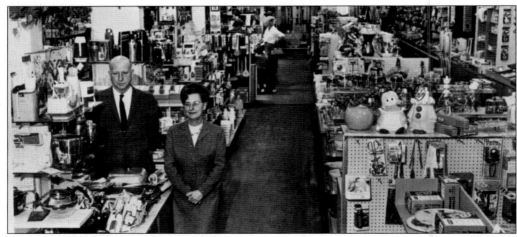

Arthur and Evelyn Wienecke were the brother and sister pair who ran the village's longest-running and most famous business for more than forty years. The siblings took over running the hardware, paint, toys, and housewares store from their father, Henry C. Wienecke, who had established it in 1902. Arthur Wienecke served as village trustee; Evelyn, "Evie," was a stalwart of the Glencoe Historical Society, serving as treasurer for almost two decades. Photo c. 1960s.

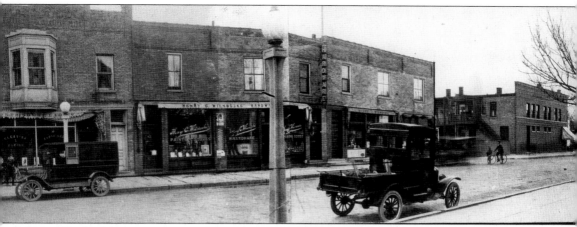

Subaru. The building was converted in the mid-1980s into three retail spaces, today home to Shellé Jewelers, Books on Vernon, and Motophoto. The Writers' Theater is located behind the bookstore.

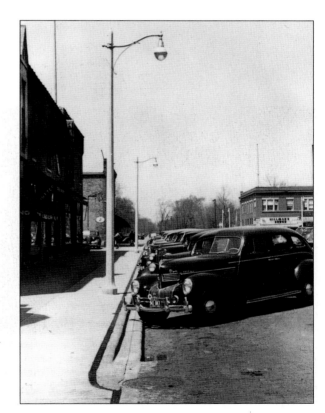

In front of Wienecke's Hardware, c. 1940s, cars are lined up; not that far removed from the vans and SUVs that line up in the same way today. Evelyn Wienecke once said, "We sell everything but groceries."

In 1896, Glencoe's first telephone exchange opened in Holste's Store, at the corner of Park and Vernon Avenues, where Henry C. Schroder (or Schroeder) served as operator. The exchange operated from 724 Vernon Avenue, above, from the 1920s until 1957. Glencoe was late to receive dial phones, in 1953. The VE 5 (835) exchange was chosen because there were too many extant GL exchanges elsewhere. In 1959, the building was sold to the Boy Scouts of America North Shore Council. When they moved in the mid-1980s, it became a residence.

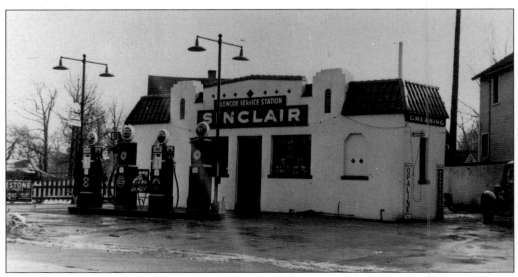

Many businesses continued to operate outside of the central business district until zoning eliminated them. This Sinclair Station, c. 1940s, was located at the intersection of Glencoe (Green Bay) Road and Vernon Avenue. It later became Gino's Standard Oil Station, owned by Gino Corra, until it was sold, razed, and replaced by townhomes.

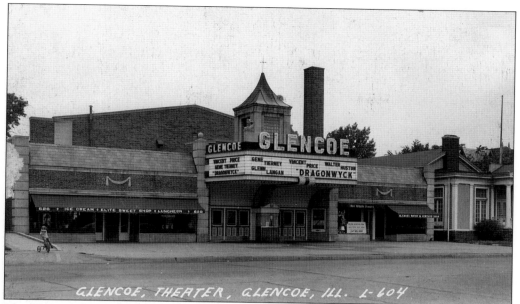

GLENCOE, THEATER, GLENCOE, ILL. L-604

The Glencoe Theater, at 630 Vernon Avenue, was designed by Chicago architect Irving M. Karlin and built in 1940. Glencoe resident Sam Meyers owned this and other Circuit Theatres, including the Teatro del Lago in Wilmette. *The Return of Frank James* was the inaugural program, October 16–17, 1940. The last program, *Heaven Can Wait*, ran Nov. 1, 1979. The theater changed movies twice a week. The Gothic tale *Dragonwyck* was released in 1946 starring Vincent Price, Gene Tierney, and Walter Huston, and was showing when the above photo was taken.

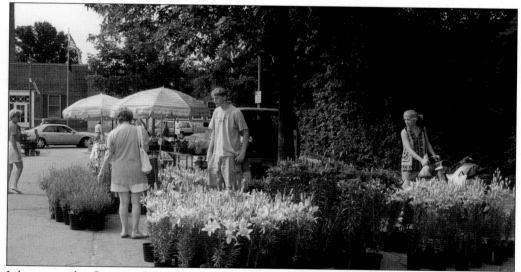

Lilies were the flowers of choice in 1999, but gladiolas and others are as much a favorite as berries, tomatoes, beans, and vegetables. The Glencoe Chamber of Commerce's summertime Farmers Market is held each summer Saturday morning along Village Court. At the end of the street, at Hazel Avenue, is the Glencoe Public Works Building. It was upgraded with a new entrance façade and additional space in the mid-1990s. (Courtesy of Glencoe Chamber of Commerce.)

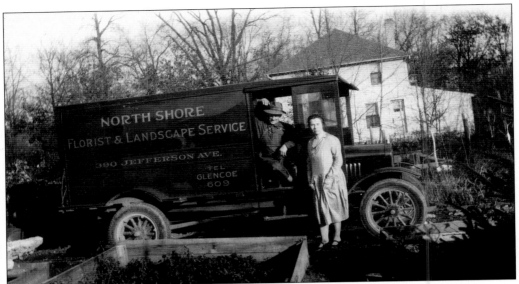

This c. 1920s photo shows the owners of North Shore Florist and Landscape Service on Jefferson Avenue. North Shore later moved to Greenwood Avenue, where it was in operation through the 1980s. The home of the Paletti family is in the back. Florists and landscapers operated many businesses on the south end of town, along the so-called Presidents Streets, until the 1920s when zoning put most of them out of business.

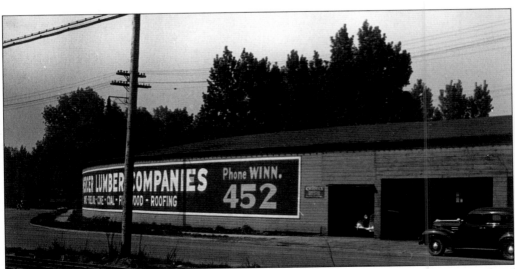

This 1939 photo looking southwest shows Mercer Lumber Companies, on the west side of Green Bay Road at the curve before Scott Street. The south end of town was home to many lumber companies, remnants of Glencoe's earliest business. They were pushed out by zoning and public demand for less noxious land uses, such as residential spaces.

Three

VILLAGE GOVERNMENT AND SERVICES

THE BODY POLITIC

Government is the invisible backbone of the village. Glencoe residents expect high quality services because that is the tradition. Myriad services are provided without hassle, including, in addition to traditional police and fire protection, water supply, street and sidewalk plowing, garbage collection, recycling, and more. Glencoe has always been on the forefront of good government. It was the first Illinois community (1914) to adopt the council-manager form of government, removing politics from the village's day-to-day operations. It was one of the first municipalities in the state to adopt a zoning ordinance and building code (1921) and is a pioneer of the concept of a public safety department, with a combined police/fire and emergency medical technician staff (1954). The village is nationally known for an administrative assistant program that trains college graduates for careers in local government, which has been in place since 1953.

Government is close to the people because of the size of the village, yes, but also because both elected officials and staff work to make it so. Glencoe residents are familiar with their government; elected officials are neighbors. Residents don't hesitate to call trustees, library directors, or school or park board members to talk about issues. Although the village once held annual town meetings, residents today still gather, now biennially (in the odd-numbered years), at a January town meeting to hear village, park, and library board presidents give status reports and nominate potential board members. Later that same year, they meet again in June to hear a status report and vote on nominations for the school board.

Glencoe's services emanate from the village center. The old Village Hall was built in 1894 along one of the two business district thoroughfares, Vernon Avenue. Razed in 1957 when the new Village Hall was built on what is now Wyman Green, the old building was the original home of the fire and police department, village staff, and the public library (second floor). Other facilities include the water plant on the lakefront, built in 1928 and doubled in size in 1954, the public works garage on Hazel Avenue, and on Frontage and Tower Roads, the blue Glencoe storage tower that stabilizes the water system. The tower is a symbol of the village—as well as a graffiti target for New Trier Township High School graduates. The land around the tower was home to the 1930 village incinerator, used to burn trash. Today, rubbish is hauled off to landfills.

From the earliest times, Glencoe has been proud of its government, knowing that elected and appointed officials and government staffers throughout the years have worked diligently to fulfill the dream expressed in the local history book, *Glencoe Lights 100 Candles*: "the best of all possible villages."

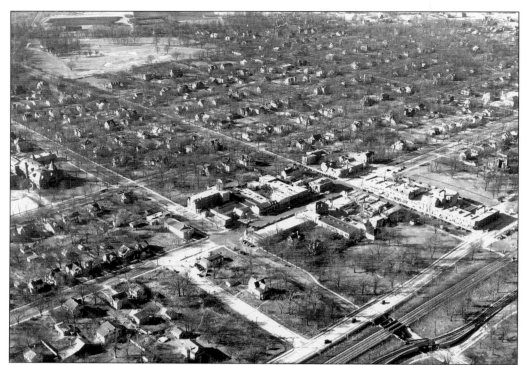

This 1935 aerial view, shows the old Village Hall on the east side of Vernon Avenue (running from south/left to north/right), the site of today's Village Court parking lot. Among today's buildings that are missing: the library, Dee Jay's supermarket, and the new Village Hall. The empty lot beside the Masonic Temple, on the southwest corner of Hazel and Vernon, was filled by the Glencoe Theater five years later.

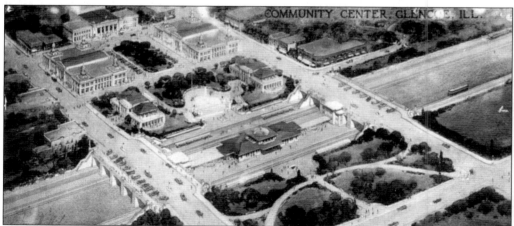

In 1919, noted architect and planner George Maher created a model for a Glencoe Community Center that was never executed. The train station is in the picture's center. Classical Beaux Arts-style government buildings surround the park squares and promenade across the street (west). Railroad tracks have been depressed under Hazel Avenue (south/lower third of the picture). The Ziesing Building at the corner of Park Avenue and Green Bay Road still stands. (Courtesy of Village of Glencoe.)

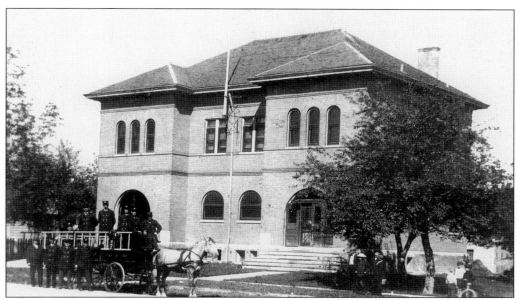

Glencoe's old Village Hall, which, at 675 Vernon Avenue, stood mid-block on the east side of the street between Hazel and Park Avenues, had a 97-foot frontage that was acquired for $1,000 in 1893. The fire brigade stands in front. The building was built in 1894 and for a long time housed the Glencoe Public Library as well. In 1917, the one-story fire engine house and police station were added. In 1933, a one-stall garage was built on the south end. This photo is c. late 1910s.

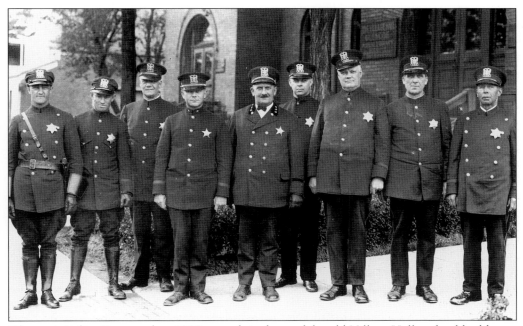

Glencoe's Police Force, c. late 1920s, stands in front of the old Village Hall and public library. The only identified members are Chief Jake Rudolph, middle, with a mustache, and motorcycle policeman Pete Kloepfer, second from left. (Courtesy of Village of Glencoe.)

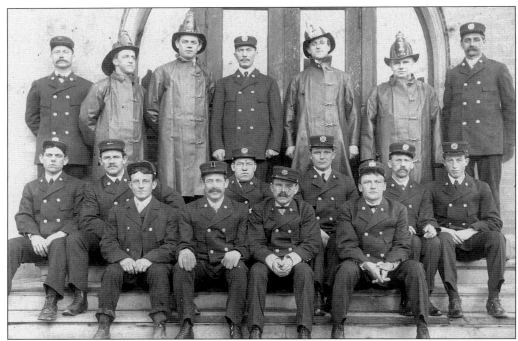

Members of the Glencoe's Fire Brigade of 1905 are pictured here on the steps of the Old Village Hall. Most of the firefighters were volunteers, often businessmen. From left to right, front row: Herbert Richardson, Walter Sieber, John Maloney, Will Harry. Middle row: Al Hamilton, William Walters, Albert Clyde, Frank Lane, Henry Mollenhauer, Edward P. Sieber. Top row: Henry C. Wienecke, John Harry, Otto Grabo, August Mrasek, Raymond Culver, Daniel McArthur, R.(?) Culver.

Glencoe's new Village Hall, 1957, designed by Furst, Maher and McGrew, of Evanston, is a Georgian-style red brick building that harmonizes with the library to the north. The building was remodeled in 1994. Offices of the public safety, public works, and finance departments and village manager are located here, as are the public safety dormitory, "jail" (holding cells), and, until the 1990s, a shooting range in the basement. (Courtesy of Village of Glencoe.)

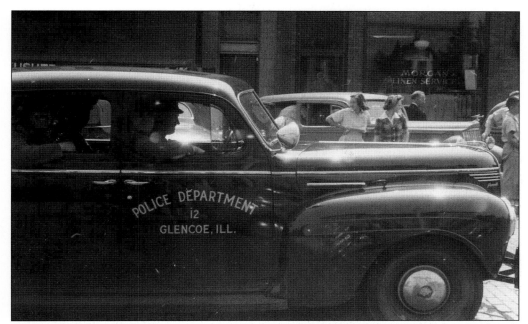

This 1940 Plymouth Police Department squad car drives along Vernon Avenue in front of Kusher Tailoring, left, obscured, and Morgan Linen Service, right, in a Fourth of July parade. The police and fire departments merged into the Department of Public Safety in 1953–54. After cross-training was initiated, an incentive pay plan was developed to give each man who volunteered to participate a 15 percent pay raise after 27 months of training.

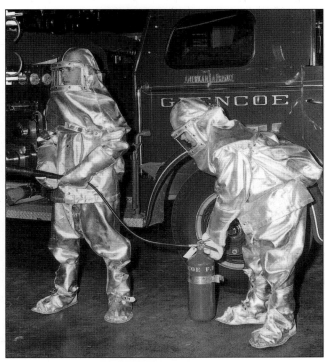

Officer Jerry Geogue, left, and an unidentified man are training for hazardous fire fighting in front of the America LaFrance engine, late 1950s–1960s. It was a far cry from 1874, when a bucket brigade was organized, or 1893 when the volunteer fire department used a hose wagon. The first person to arrive with a horse after the alarm sounded received $4 for hauling the wagon. (Courtesy of Village of Glencoe.)

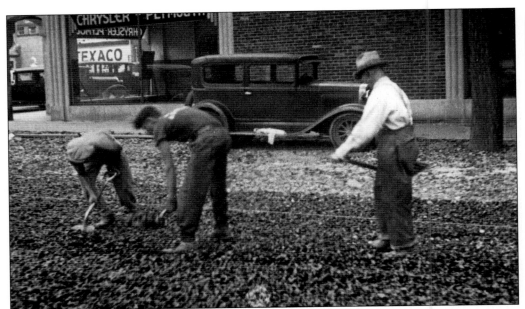

Street work was an important part of village efforts even before the official establishment of the Department of Public Works in 1957. Here, a 1930s crew appears to be laying asphalt along Hazel Avenue. The department, responsible for village infrastructure, houses its garbage trucks, trash collection scooters, and snow plows in the Public Works Garage on Temple Court. The more than 37 miles of Glencoe streets have been resurfaced and improved under a program begun in 1987. (Courtesy of Village of Glencoe.)

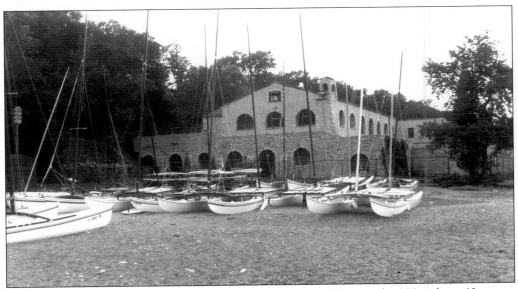

Each house had its own well or carried water from the lake until 1892, when 60 voters petitioned for something better. Mains were laid to connect to the new Winnetka water works. Glencoe built its own water plant in 1928. Many homes in Glencoe did not have their own running water or indoor plumbing until well after the turn of the century, some as late as 1920. (Susan Myrick photo)

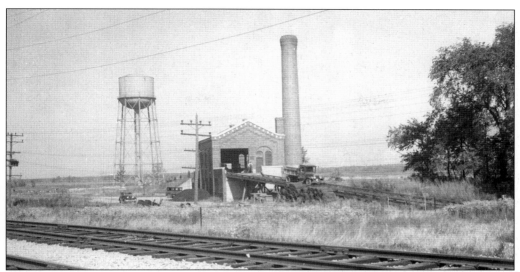

In 1927, an incinerator was built on a five-acre site at Skokie Boulevard and Tower Road, the southwestern corner of village limits. The plant, which also served Winnetka, consumed thirty tons of garbage every 10 hours. The incinerator closed in 1959, a reaction to the changing attitudes about garbage disposal; the plant was obsolete. The building was demolished sometime after 1983; the smokestack in the early 1990s. This photo is dated 1935.

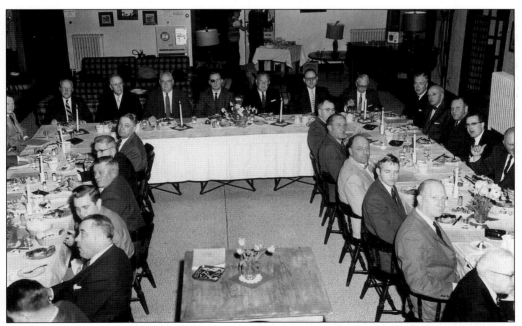

A 1958 retirement party for Jim Williams, Director of Public Works, took place at the Glencoe Golf Club. Nine holes of the club are on land owned by the Cook County Forest Preserve, and nine are on village land originally purchased for an incinerator. Pictured at the head table are as follows: (left to right) William Spencer Crosby, Village President William J. Hagenah, Mr. Williams, Sherman R. Barnett, Leonard Cowan, Village Manager Robert Morris, and John Fischer.

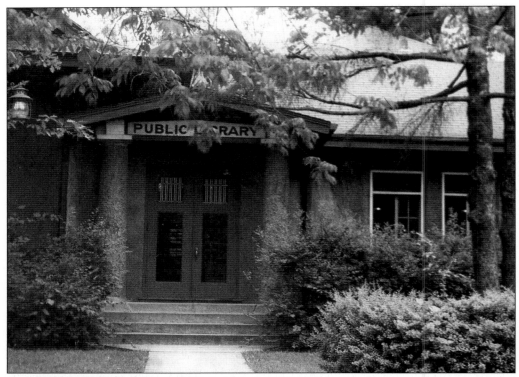

The Glencoe Public Library was organized in 1909 with a collection from the Woman's Library Club, Glencoe schools, and the Congregational Church. The first location was in old Central School. Sarah Hammond, daughter of founder Alexander Hammond and a teacher, was the first librarian, serving until 1935. The second location, 1912–1929, was the old Village Hall. From 1929 to 1941, the library was in the "Hawthorne School," above, at the northwest corner of Greenleaf and Hazel Avenues in the original Woman's Library Club building.

In 1941, the present library building was built on property purchased in 1917 from William H. Johnson. The interior of the library has been redone twice in the past three decades, each time to create more room for books and programs. Children's programming has always been important, whether the Children's Room was on the first floor south side of the building (1950s–1970s), in the basement (1980s–early 1990s) or, today, on the second floor. (Courtesy of Village of Glencoe.)

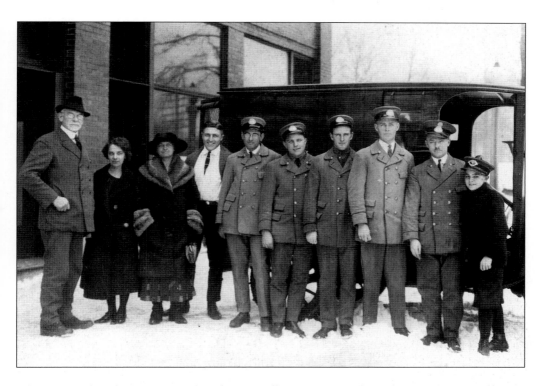

Glencoe's earliest history was tied to the post office. Anson Taylor's LaPier House was the first home to a post office in what was then Taylorsport. Alexis Clermont, on horseback, used the Green Bay Trail to deliver mail between Little Fort (Waukegan), Milwaukee, and Fort Howard (Green Bay, Wisconsin). The official Glencoe Post Office was established September 26, 1857, and has served continuously except for two weeks in 1886 (reason unknown). The 1859 receipts of $4.88 was a low, with revenues continuing to rise through the years—along with the cost of stamps. This was the post office staff in the 1930s, when the post office was located along Glencoe (Green Bay) Road in the Zeising Building. The current post office on Hazel Avenue was dedicated in July 1958. Below, a 1938 commemorative envelope for National Air Mail Week shows an artist's vision of the LaPier House Post Office of 1849.

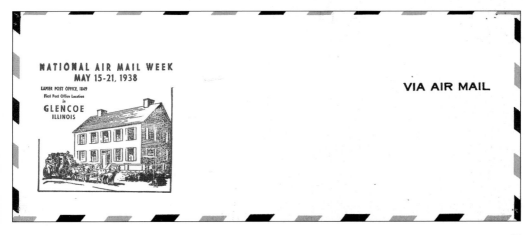

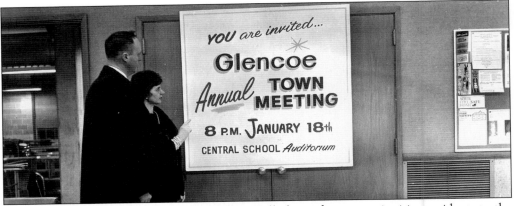

Charles and Betsy Mack stand in the Village Hall alongside a poster inviting residents to the annual Town Meeting. Although today the meetings are biennial (due to the state's Consolidation of Elections Act that eliminated annual municipal elections), the tradition of government officials reporting on the status of each board—village, park, library, and school—continues. (Courtesy of Village of Glencoe.)

C.C.132

SPECIMEN BALLOT

Glencoe Village Election, April 5th, 1898

○ **Glencoe Village** TICKET	○ **Glencoe Citizens'** PARTY	○ **Independent**
For President, ☐ JOHN FANNING.	For President, ☐ JOHN L. DAY.	For President, ☐ JOHN R. JAMES.
For Councilmen, ☐ O. F. POOLE, ☐ L. H. LLOYD, ☐ GEORGE PARK, ☐ SYLVAN NEWHALL, ☐ CHAS. FRED. DUPEE.	For Councilmen, ☐ MARKHAM B. ORDE, ☐ GEORGE DIETTRICH, ☐ JAMES K. CALHOUN. ☐ JACOB BECK, ☐ JOHN S. TAYLOR.	For Councilman, ☐ JAMES F. DENNIS. ☐ ☐ ☐ ☐
For Collector, ☑ ASHBEL G. LIGARE.	For Collector, ☐	☐
For Street Commissioner, ☐ GEORGE BRANDEL.	For Street Commissioner, ☐ HUGO EISENBERGER.	☐
For Marshal, ☐ A. W. RETSINGER.	For Marshal, ☐ CHARLES UPFIELD.	For Marshal, ☐ FRED. GRABO.
For Police Constable, ☐ JOHN B. MEANEY.	For Police Constable, ☐	☐
For Police Magistrate, ☐	For Police Magistrate, ☐ OTTO R. BARNETT.	☐

ALL RESIDENTS OF GLENCOE, ILLINOIS

DIRECTIONS.—To vote whole ticket make **X** in ○ at head; otherwise make **X** in ☐ opposite each name voted for.

Prior to 1936, Glencoe had contested elections, as this specimen ballot shows. Politics were turbulent. The Caucus Plan was adopted in 1936, with the idea that if committees of residents, today elected community-wide by precinct, would select slates of nominees they could run unopposed, eliminating contentious politics. The caucus plan's motto is "the job seeks the man (woman), the man doesn't seek the job." With a few exceptions, most elections since 1936 have been uncontested.

Four

SCHOOLS

ONE ROOM TO THREE SCHOOLS, EXCELLENCE IS KEY

Education in Glencoe is a major focus of the village. Glencoe School District 35 oversees a fully-developed public school system from kindergarten through eighth grade. High school students attend New Trier High School in Winnetka, and numerous private and parochial schools in nearby towns. Five nursery schools in the Village serve the preschool population. The public schools enroll 1,350 students, and in 2002 there are more than 125 certified staff and administrators in the District's three age-centered schools. The schools offer a rich curriculum and are nationally recognized for their excellence.

Today's Glencoe schools are a long way from the one-room schoolhouse sponsored by early settlers William Turnbull and his wife on property near Montgomery and Green Bay Roads. There, students sat on wide plank benches beside a huge fireplace. Mr. Boquet, the schoolmaster, taught all grades. The second schoolhouse was also on Green Bay Road, south of Hawthorne Avenue. This was a frame structure on cedar posts with a large box stove in the center and rough walls painted black to use as blackboards. Although co-educational, the girls entered through the north door and the boys through the south door.

Students were moved to a new schoolhouse on Greenwood Avenue north of Park Avenue in the early 1870s. It was a two-story white frame structure with wide halls, long windows, two stairways, and a large basement. There were three classrooms. An ideal playground is recounted in an early history of Glencoe: "In the Spring, long-stemmed violets were abundant, and in autumn days the winter's store of nuts lay beneath the trees. In colder weather, skating ponds were all about in the undrained swampy land." Oratorical exercises were introduced in 1878 and Latin was offered as an elective. Excursions were part of the curriculum; in 1893, the students visited the World's Columbian Exposition for two days.

The schools were under the control of the village board until the population reached 1,000. In 1896, a Board of Education was elected. The first Central school was dedicated in 1898 to alleviate the crowded classroom situation. Some primary grades had been meeting in a leased store before that. The village continued to grow and new schools were built, expanded, and—in the 1970s—closed. Through the years, Glencoe schools have maintained their commitment to children and families, providing excellent teachers and administrators, an enriching curriculum, and lasting memories for all who have attended.

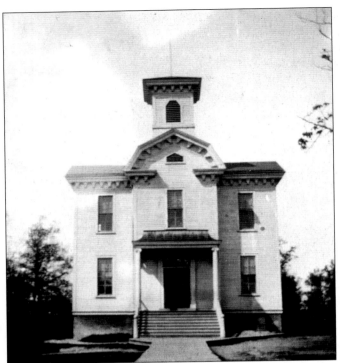

In December 1872, Glencoe erected a "commodious building" to house its school, at a cost of $3,125.40 plus $50 for the architect. The school, a white frame structure, was situated at about 780 Greenwood Avenue, north of Park Avenue. The building burned in 1876, but fortunately was insured and rebuilt. Eventually, after the Central School opened in 1898, the old wooden schoolhouse was moved to Vernon Avenue in 1904 and became part of Wienecke's Hardware Store.

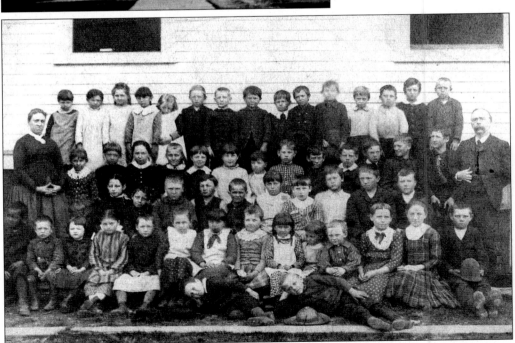

This picture of Glencoe school children was taken outside of the white frame school building on Greenwood Avenue. The teachers are Miss Ida Law, far left, and Professor Matheson, far right. The photograph may date from the mid-1880s since Professor Matheson is recorded as principal at that time.

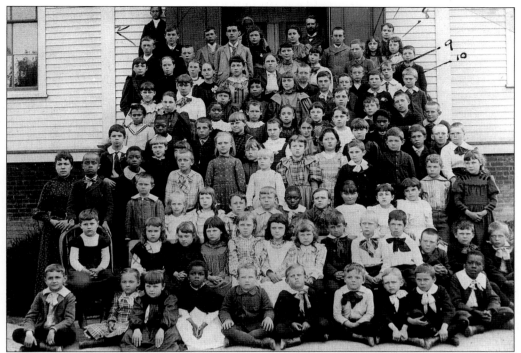

Children of the Glencoe Public School in 1892 posed on the front steps for a photograph. By this time, the school enrollment was taxing the capacity of the building, and rooms in other buildings were occasionally leased. Many of Glencoe's early families are represented in this photo, including the Newhalls, Hurfords, Wilsons, Diettrichs, Culvers, Gormleys, and Schramms.

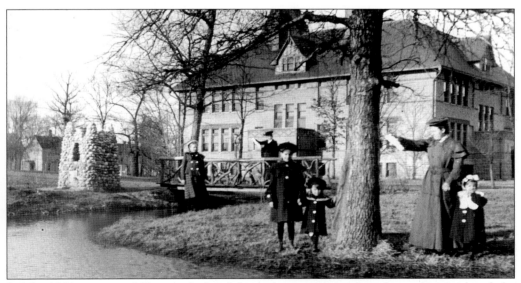

In May 1894, citizens of Glencoe declared themselves unanimously in favor of issuing bonds for a new building. Lot 25 on Greenwood Avenue, south of Hazel Avenue, was selected as the school site. This is a photo of the original Central School, built in 1898. The water was a man-made lake on the grounds and the small stone tower is a decorative drinking fountain.

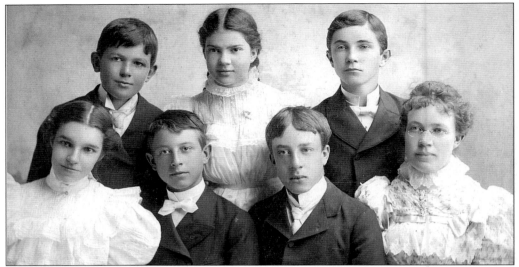

These children and their teacher are part of the Central School class of 1898, the year the school opened. The teacher, pictured at the right, is Miss Love. Although not identified specifically, the children are Elizabeth McArthur, Eddie Flanders, Eddie ?, Emma and Sinclair Willmarth, and Gus Levernier.

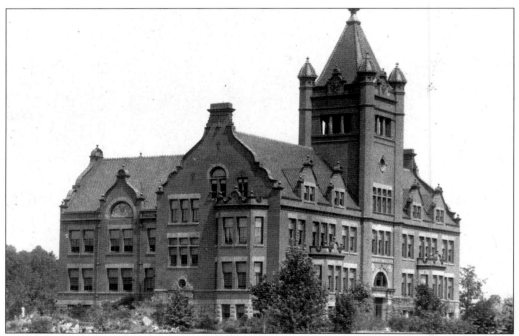

With the increasing population of the villages along the North Shore in the 1890s, it became necessary to establish a high school. New Trier Township organized into a high school district, and General C.H. Howard of Glencoe became a member of the first Township Board of Education. An election determined the location of a six-acre parcel in neighboring Winnetka, close to train transportation. On a snowy day in February 1901, New Trier opened, serving towns from Wilmette north to Glencoe.

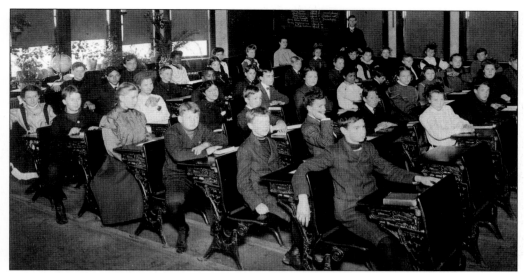

This is a photo of a classroom at old Central School in 1907. The second student from the right in the second row from the front is Archibald MacLeish, the future acclaimed poet. MacLeish is about fourteen years old in the picture.

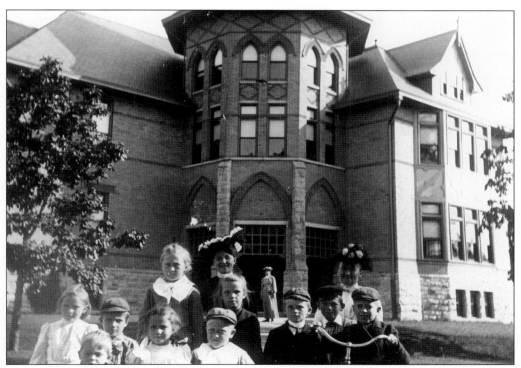

This picture of children and teachers at old Central School was taken in 1901. The architect of the first Central School was John J. Flanders of Glencoe. Flanders was instrumental in the rebuilding of Chicago after the Great Fire of 1871, designing the Mallers Building, 1884–85, one of the earliest skyscrapers. He was also the architect for the Chicago Board of Education. (Courtesy of Diettrich family.)

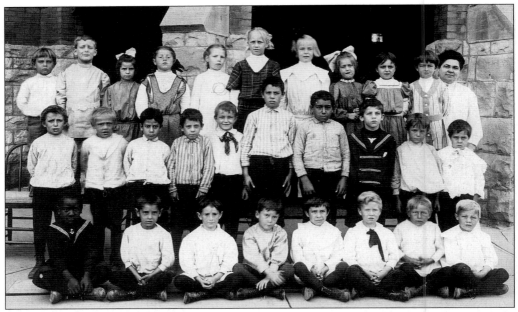

A class of children at the old Central School pose for a picture c. 1910. The children in the back row are standing on a board balanced on chairs. The boys are wearing knickers, the customary dress of the day. (Courtesy of Diettrich family.)

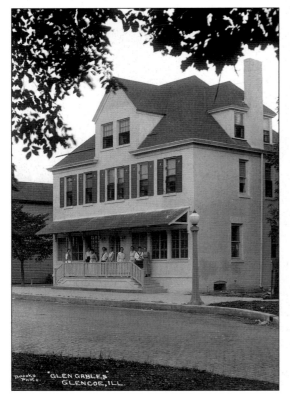

Built in the 1890s, this building on the south side of Park Avenue was originally the Glencoe Hotel (although some references have recorded it as the Harry Hotel). It housed workers who built streets and railroads. In 1920, when the housing of teaching staff became a problem due to few and costly accommodations in town, three hundred citizens formed a trust and subscribed to a $30,000 public purchase of the old hotel. It was converted into apartments for the teachers. Then known as Glen Gables, the apartment house operated until the Depression.

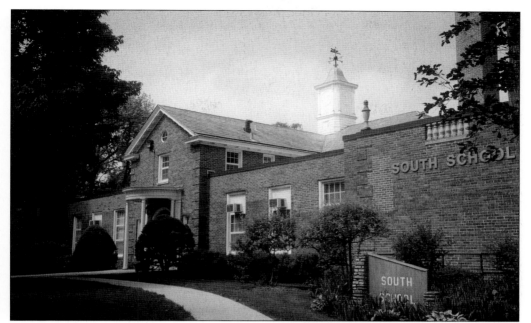

In 1923, because of overcrowding at the old Central School, classes met across the street in the basement of Trinity Evangelical Lutheran Church. To serve the expanding school population, South School was completed in 1926. Opening with kindergarten through third grades, fourth and fifth grades were added in 1927 and 1928 respectively.

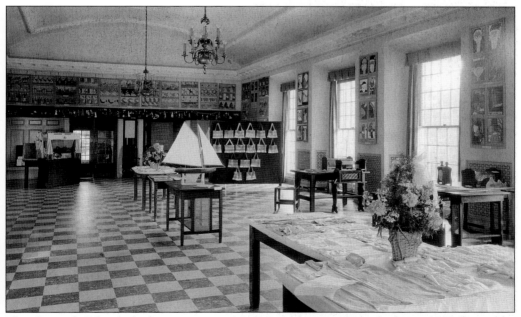

The Central School Auditorium, now Misner Auditorium, was built in 1928 by public subscription. The community room above the lobby has been the scene of many activities including dancing lessons, Caucus meetings, and PTA events. Above, a school arts show is underway. (Courtesy of Glencoe Board of Education.)

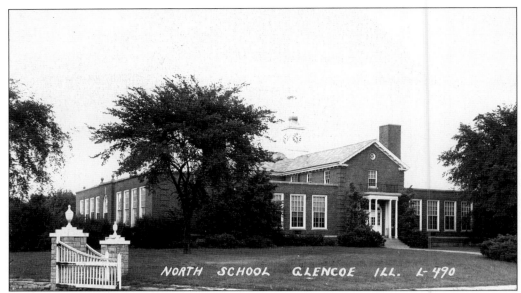

North School on Green Bay Road was opened in 1928. As a result of the World War II baby boom, a twelve-room addition was completed in 1953. It closed in 1979 due to declining enrollment and is now the Glencoe Park District Community Center. Nursery schools, a day care center, fitness programs, gymnasium and park district programs, and offices now utilize the space.

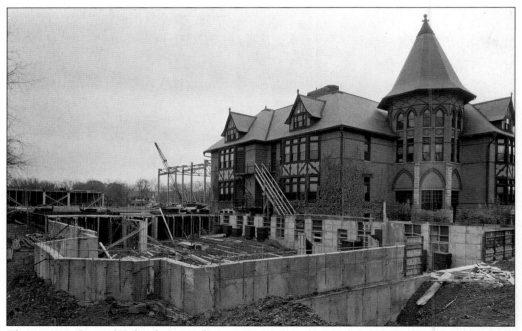

The current Central School was under construction in November 1938, adjacent to the 1898 school building. The new building was erected to the east and south of the old. Hazel Avenue had been a through street, but was closed when the new school was built. The houses on the block to the north were torn down or moved to create the playing fields that are enjoyed today. (Courtesy of Glencoe Board of Education.)

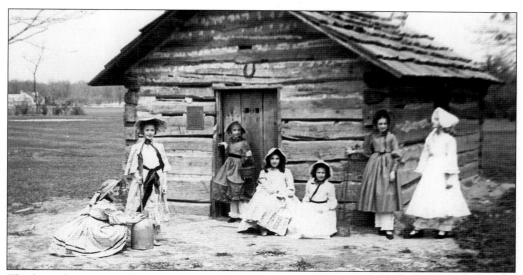

The log cabin pictured here was originally built about 1848 by Veit Diettrich, an early settler. Part of his eighty-acre property eventually became the grounds of North School, today's Community Center. The log cabin was relocated for a time from west of Green Bay Road to the North School playground area, but was later demolished. In 1938, a group of schoolgirls reenacted pioneers days at the cabin.

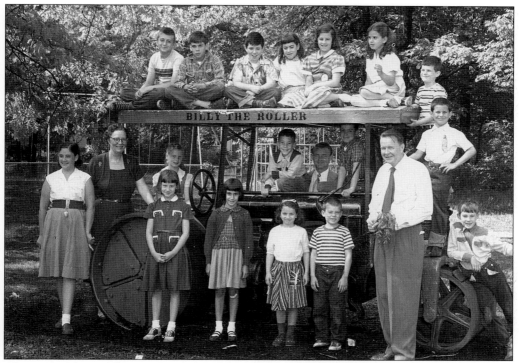

Above, members of the South School student council and principal Zoa Favoright receive new playground equipment, including Billy the Steam Roller, from Superintendent of Parks Robert Everly. This photograph is dated September 1953.

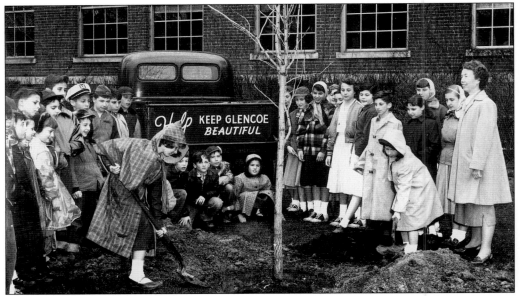

School children at Central School planted trees to beautify the grounds in the mid 1950s. Dottie Dodd, a long-time Central School teacher, is pictured at the far right.

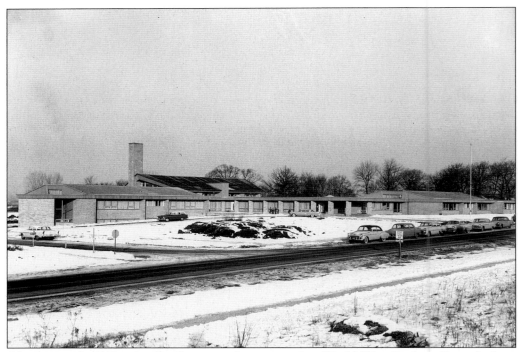

Glencoe south of Dundee Road grew in large part after World War II when Greta Lederer developed Strawberry Hill. More homes necessitated the opening of a fourth school for Glencoe. West School opened in 1957. It closed in 1976 due to declining student population, but reopened in 1991 as the "echo boomers" increased Glencoe's school population. (Courtesy of Glencoe Board of Education.)

Five

PARKS AND RECREATION

SUN, WATER, AND LOTS OF GAMES

One of the main features of Glencoe has always been the thick forest situated atop a high bluff along Lake Michigan. Early settlers sought the lake's coolness in the summer and its moderating effects in the winter. Those seeking to escape the congestion of the city moved to the sylvan area of Glencoe, close to an ideal of the "country life." Yet, the city was still easily accessed by train and eventually by car as well. Dr. Alexander Hammond and the early founders, in their foresight, set aside a full block of land at the lakefront between Park and Hazel Avenues. It was intended to be used as a park in perpetuity. The Park District was created in 1912 to promote the creation of parks in Glencoe and inhibit development by business and industry, particularly east of the railroad tracks.

Think of recreation in Glencoe, and think of the seasons. In summer, there are the long, lazy days at the beach enjoying a swim in Lake Michigan or sailing a sunfish. In the winter, there are afternoons of skating at Watts, sledding the hill or cross-country skiing on the Green Bay Trail. Fall is filled with weekends of soccer and football. Spring finds the baseball diamonds full again. And always, there are the cyclists on Sheridan Road or the Green Bay Trail, golfers teeing up, joggers and walkers, and people playing tennis in the village's many parks. The numerous playgrounds such as Friends and Phil Thomas Parks are in constant use by Glencoe children.

The Park District offers many programs for citizens and maintains acres of open space. There are classes in art, camps for kids, special events for the holidays, and outings—canoeing, skiing, or fishing. Summer concerts in Kalk Park are eagerly anticipated. In 1996, the Park District adopted the District's first Open Space Master Plan, which maps its short and long-term direction. Major renovation projects at Watts Center and Lakefront Park were completed recently.

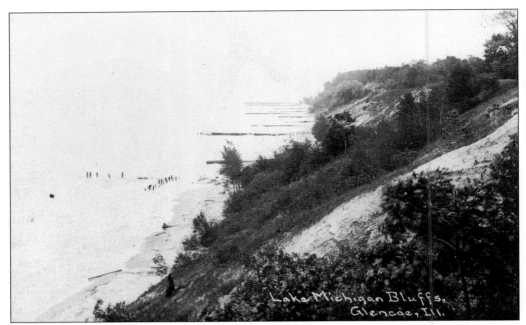

The Village of Glencoe is built on a glacial moraine, or ridge, composed of loose glacial soil. The wave action of Lake Michigan has cut back the east side of the moraine, creating steep slopes 75 feet above the beach. Residents and the Village have built groins (piers) into the lake, seen here, to control shoreline erosion and to build up the beach. This is an undated early view of the bluff and beach.

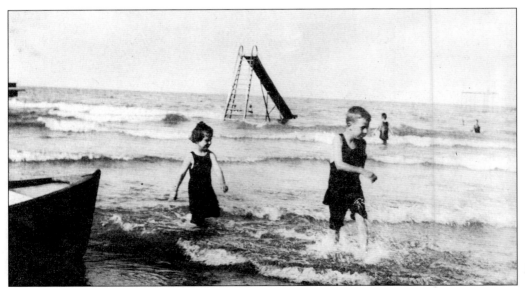

Cooling off at the Glencoe Beach has been a delight for children for decades. Before 1915, it was not healthy to swim in Lake Michigan because of the flow of raw sewage from the Chicago River into the lake. In December 1915, the opening of the Chicago Sanitary Canal reversed this flow. In Glencoe, the Park Board erected a frame beach house with showers at the Glencoe Beach. In 1917, Evelyn and Art Wienecke splash in the waves.

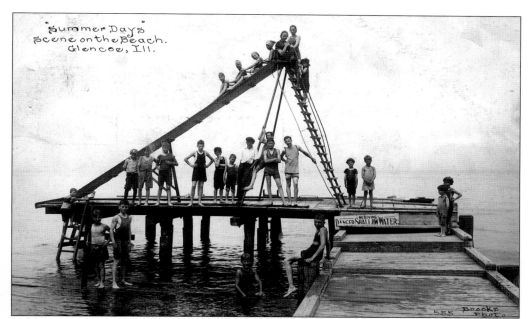

In the 1920s, the pier at the Glencoe Beach featured a slide into the water. A group of Glencoe youngsters pose for a Summer Days postcard scene. One piece bathing suits were boys' apparel.

Until the 1940s, separate beaches were maintained in Glencoe for African-American and white residents. In the 1940s, Albert Foster, an African-American resident, sued the Park District to force it to sell him a beach token for the white beach. Foster won the case and the beach at Park Avenue was opened to all races. The African-American beach had been located at the foot of Harbor Street. This is a scene from the 1920s.

The Halfway House, approaches, and beach house were built in 1928 under the supervision of Paul Battey, then president of the Park Board. Battey was an engineer who drew up the plans and supervised the development of Lakefront Park and the beach area at the time. In addition, he designed the limestone exterior of the water plant to harmonize with the architecture of the other beach buildings.

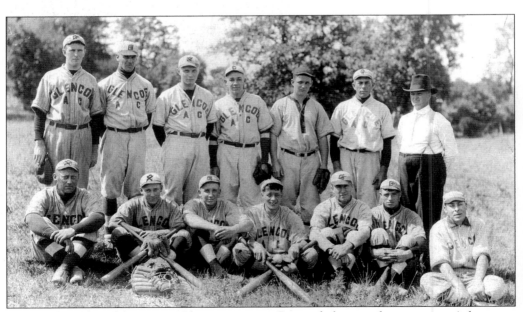

Baseball has a long history as a Glencoe pastime. Pictured above is the young men's league *c.* 1930, sponsored by the Glencoe Athletic Club.

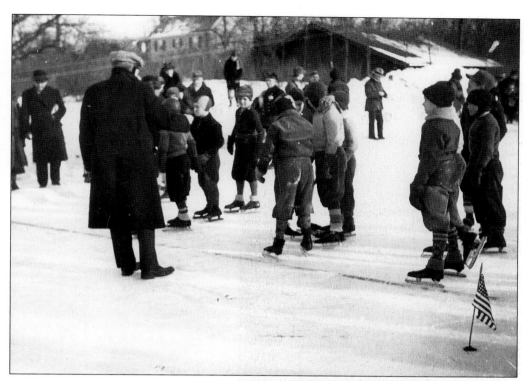

Before Watts Ice Arena was constructed on Randolph Street, flooded fields were used for ice rinks. Above, skaters line up for the relay race for boys under twelve at the second annual ice carnival, February 1936. Participants brave the sub-zero weather to race at the north rink on Green Bay Road, a flooded field between Dennis Lane and Lincoln Avenue.

The three-acre park adjacent to South School was established in 1932 as a wildflower sanctuary preserving species of wildflowers indigenous to Glencoe. The Civilian Works Administration made it possible to utilize unemployed labor during the Depression to improve the park with winding paths, a pool, and a rustic bridge. In 1962, the sanctuary was dedicated to Robert Everly, Park District superintendent for thirty years.

The Skokie Lagoons lie in a valley west of Glencoe and comprise part of the watershed of the north branch of the Chicago River. By 1933, the Cook County Forest Preserve District acquired most of what was the Skokie marsh, an area of peat that flooded in the spring and caught fire in the fall. For nine years, ten companies and several thousand Civilian Conservation Corps workers moved four million cubic yards of earth to create the scenic Lagoons area of today.

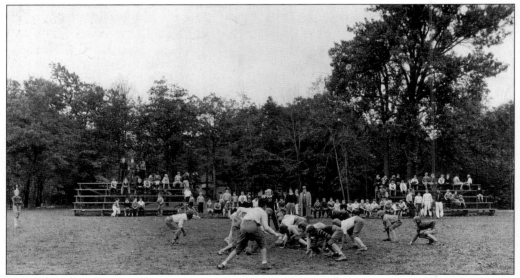

In 1931, Robert Everly, parks superintendent, and John McFadzean, physical education director of the Glencoe schools, conceived of the idea that every public school should have an adjoining park area. The concept was first implemented in the property adjoining North School. It eventually was implemented for all Glencoe Schools. In 1938, above, a football game is played in Watts Park, adjacent to South School.

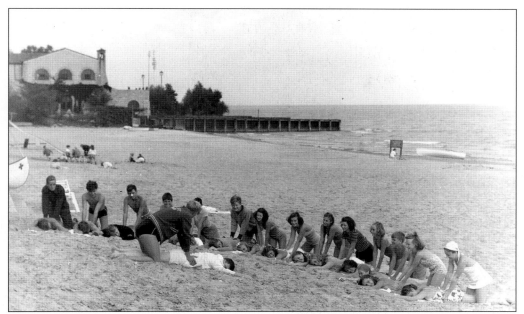

The Glencoe Park District has been teaching residents skills for emergency life saving for more than half a century. Above, a class learns artificial respiration at the beach in 1940. In the background is the Village's water works.

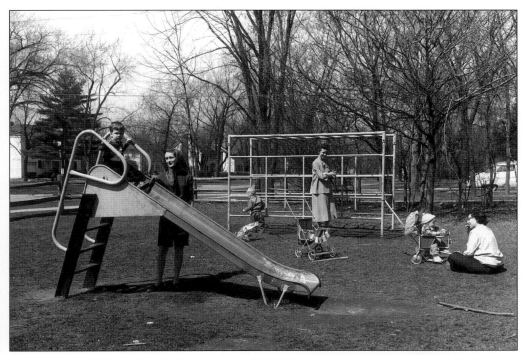

Playgrounds are abundant in Glencoe. A popular gathering place is Friends Park in the center of Glencoe, near the Woman's Library Club. This scene is from fifty years ago, when mothers and their children enjoyed the park much as they do today.

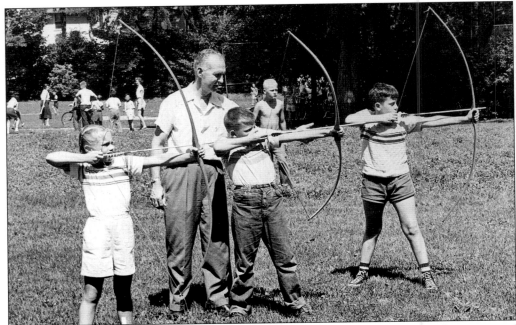

A cooperative program between the Glencoe Park District, the Board of Education, and Glencoe Playgrounds, Inc., the Glencoe Youth Activities program gave children a balanced program of physical and creative activities in the summertime. The events were planned with an objective of making maximum use of Glencoe's public parks and school playgrounds. This archery lesson was in the summer of 1952.

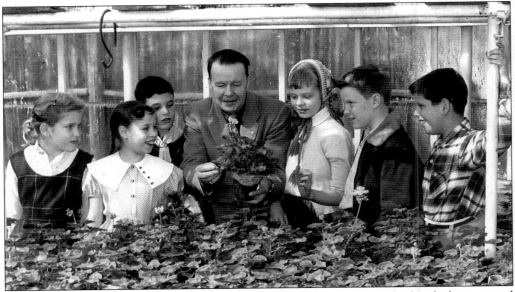

In 1956, Superintendent of Parks Robert Everly explained the methods of planting and transplanting geraniums to Glencoe children. For many years, the Park District has maintained greenhouses for the propagation of plants to beautify Glencoe parks. Today, residents are able to purchase plants from the greenhouses as well.

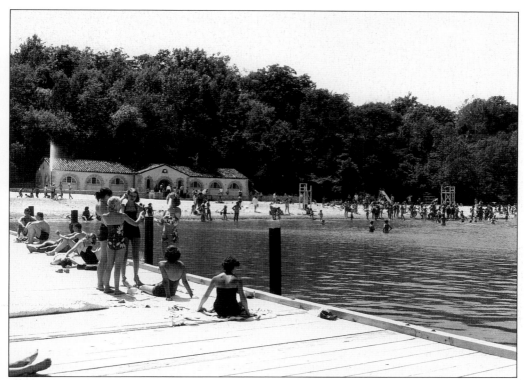

Built in 1928, the beach house is an example of Spanish Revival architecture with its tiled roof, arches, and stucco walls. In 1930, a violent storm damaged the terrace of the beach house. As the result of the long pier, the sand has accreted gradually over the years, and the beach has grown quite wide, protecting the beach house from further storms. This is a scene around 1960.

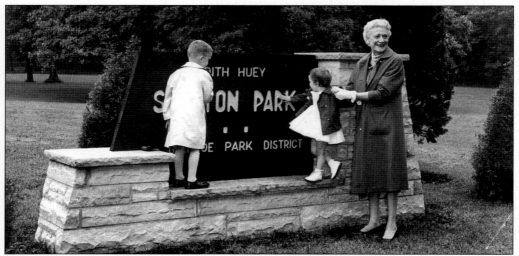

Shelton Park at Harbor Street and the railroad tracks was dedicated in June 1960 to honor Edith Huey Shelton, shown here, who was president of the Park District Board and the first woman on the board. In the mid-1800s, Shelton Park was the site of a sawmill that supplied wood for the steam engines on the railroad.

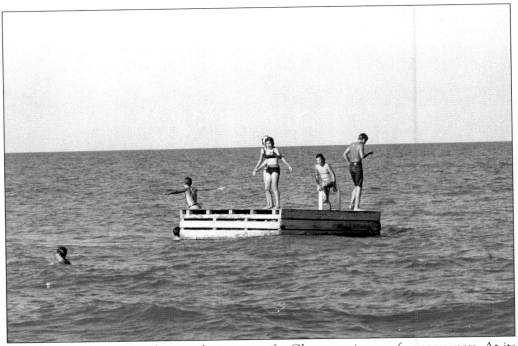

The diving raft at the beach was a favorite spot for Glencoe swimmers for many years. At its peak, there were two diving rafts and a diving tower with two levels for diving. The raft floated on 55-gallon drums and was anchored by a railroad car wheel.

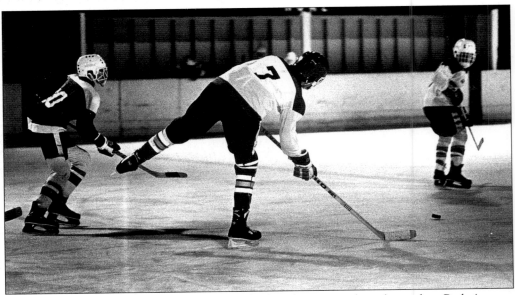

Skating is a major winter sport in Glencoe. The first skating pond was located on Park Avenue from around 1914 until 1936, when it was moved north to Green Bay Road and Dennis Lane. In 1960, another rink was opened adjacent to Central School, with a shelter. In 1972, the Park Board installed artificial ice rinks at Watts Center, which had been built in 1958 to house community activities and the Park Board offices.

In 1963, the Cook County Forest Preserve District and the Chicago Horticultural Society collaborated to establish a botanic garden for the region. The site selected is reclaimed from the Skokie marshland in west Glencoe. It was once a portion of Robert Daggitt's Glencoe farm, settled in 1839, and it served as the watering hole for his herd. To create the garden, which opened in 1972, the land was drained and sculpted into waterways, islands, and hills.

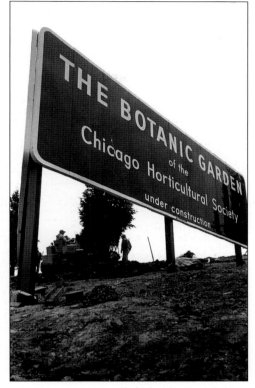

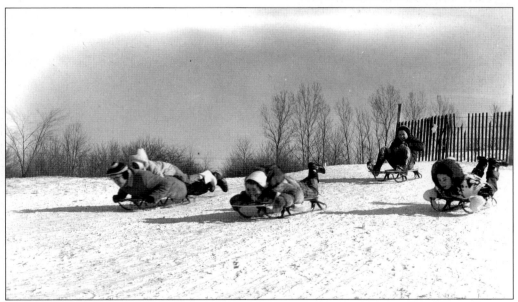

In the wintertime, children enjoy the sledding hill located across the street from Watts Center. The hill was created from clay excavated at Lakefront Park during the installation of a two million-gallon underground reservoir. The storage tank for the reservoir is under the tennis courts at Lakefront Park.

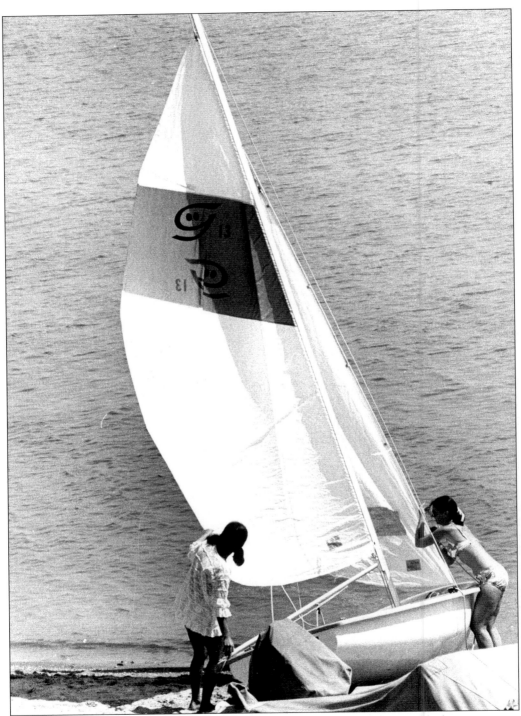

Rights to the use of the sailing beach at the lakefront were made possible by a generous donation from the Perlman family in the mid-1960s. A sailing beach separated boaters from swimmers for greater safety.

Six

VILLAGE LIFE

JOINING UP, JOINING IN, CONTRIBUTING SERVICE

Not long after its inception, Glencoe residents began to congregate for various activities and interests. The Village is a diverse, dynamic, committed population, which reflects the 21st century United States while at the same time strongly upholds ideals of the Village from its mid-19th century birth. Some groups have thrived and then faded away with changing times. Others have long-standing roots in Glencoe life. One of the earliest groups to form, the Woman's Library Club, met early on to share letters from a traveling neighbor and to discuss books. This led eventually to the founding of the Glencoe Public Library. The myriad of book groups that meet each month in Glencoe carry on this tradition of meeting for "intellectual and social improvement." Other groups share interests in the arts and learning, including the Friends of the Glencoe Public Library, Glencoe Chapter of Lyric Opera, the Glencoe Garden Club, Village Gardeners of Glencoe, and the Actors Theater of Glencoe.

The Village of Glencoe is strongly identified with its orientation to families. Numerous activities exist for children and parents together. Scouting has long been a part of growing up for many Glencoe children, with overnights at Little House, marching in the Village parades, and participation in service projects as long-standing rites of passage. Glencoe Junior High Project and Glencoe Youth Services provide activities for the middle and high school populations.

Other service-oriented groups and organizations such as Rotary Club, Family Counseling Service, and United Way of Glencoe thrive. The Daughters of the American Revolution and the Patriotic Days Committee support the Village's observance of national holidays. The League of Women Voters and the Village and Schools Nominating Committee participate in the American democratic tradition of involvement at all levels of government. Outlets for recreation exist through the Baseball Association, American Youth Soccer Organization, and the New Trier Hockey Club. Lake Shore and Skokie Country Clubs are gathering places for recreation and social activities. The Glencoe Newcomers Club welcomes those who have moved to Glencoe. The Historical Society promotes the preservation and study of Glencoe's past. The Chamber of Commerce encourages a thriving business community.

Glencoe, with a population just under 9,000, contains a wealth of choices—activities and interest groups for its citizens. Glencoe residents can engage their many talents and join together with others for fun, knowledge, and service.

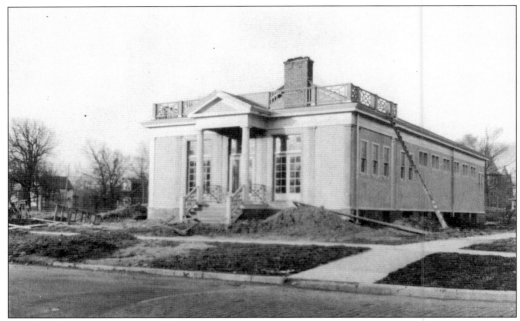

The Masonic Lodge, built in 1918, was located at the southwest corner of Hazel and Vernon Avenues. The building was occasionally rented for other events such as dances, but it was mostly used for members of the Masonic Lodge. Men would assemble for "smokers"—get-togethers with singing, slideshows, speakers, or cigar smoking—as long as there were no women present. The building was demolished in 1966. The old Central School on Greenwood Avenue can be seen faintly in the background, right.

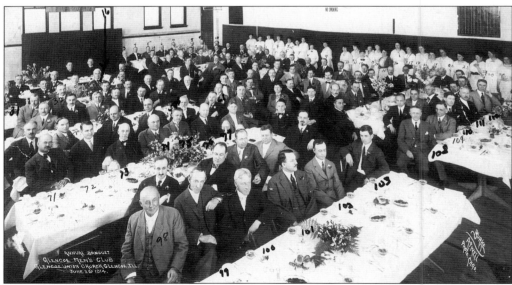

The Glencoe Men's Club, no longer extant, was open to all men in the Village. It was organized for the purpose of enlisting active interest in community affairs and of promoting good fellowship. The club held frequent "smokers" for the discussion of local affairs. Pictured above is a gathering of the club at the Union Church in 1914.

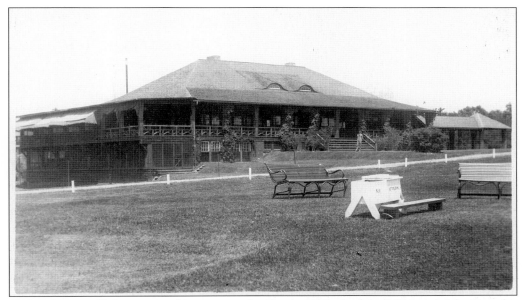

Skokie Country Club was started by a group of golfers in 1897 who leased 75 acres of the Gormley Farm for a nine-hole course. The first clubhouse was built near Adams Street at Grove Street and was later moved to its present site at Washington Avenue and Grove Street. The course was gradually expanded to a championship 18-hole course, where the National Open was held in 1922.

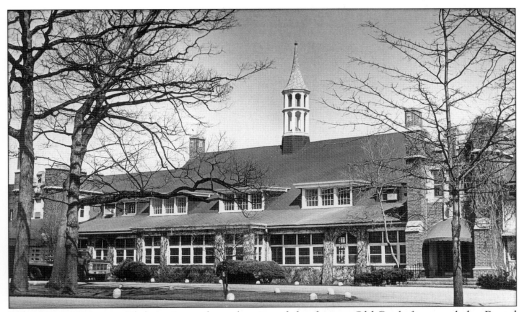

Lake Shore Country Club is situated on the site of the former Old Beck farm and the Brand property in the far northeast corner of Glencoe along Lake Michigan. It is composed of 300 acres, including a golf course near the ravines and the Green Bay Trail, a clubhouse with pool and tennis courts, and an expansive lawn area. Noted architect Howard Van Doren Shaw designed the preserved clubhouse.

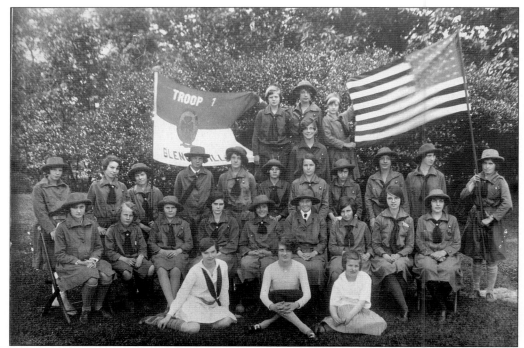

The first Girl Scout troop in Glencoe was organized in 1921. Over the years, many girls have participated in the scouting program from Brownies through Senior Scouts. Pictured above are Troop 1 Glencoe Girl Scouts in 1926.

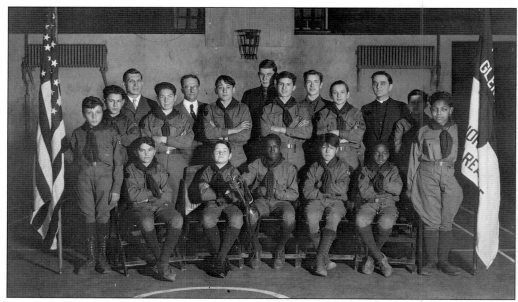

Boy Scouts in Glencoe began in 1912, just two years after the founding of the national movement. The scouting program provides boys from Cub though Eagle Scout with activities including first aid training, outdoor skills, camping, and social service. Troop 25, above, posed in 1931 and was sponsored by St. Elisabeth's Church.

The recently built Woman's Library Club is pictured in 1938. The Club began its 1938–39 season with a membership of more than 300 women and a musicale presented by the Chicago Opera Theater. The Club is one of the oldest groups in Glencoe, founded in the early 1870s. Since then, the Club has pursued its purposes of intellectual and civic improvement and social service. The Glen Cote Thrift Shop on Hazel Avenue supports the Club's philanthropic work.

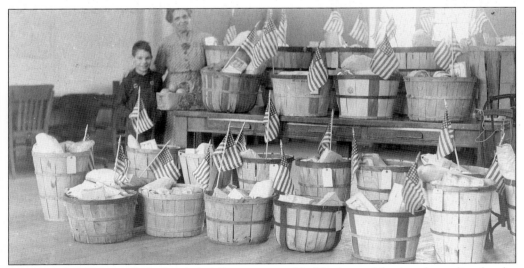

In 1941, the Glencoe Relief and Aid Society assembled baskets of food and supplies for the Christmas season. The director of the society, Mrs. Harry D. Wylie, is pictured above. The Relief and Aid Society was the precursor to Family Counseling Service of Glencoe, and was housed in the old Village Hall.

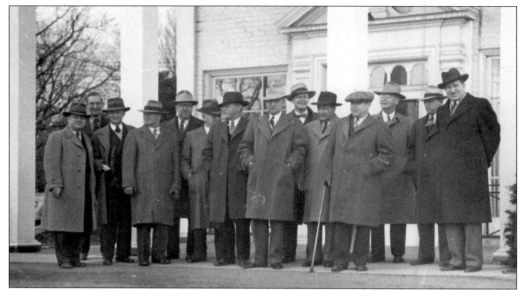

The Glencoe Rotary Club began in 1930 as an organization of business and professional men who gathered for fellowship, civic improvement, and community service. Today, women are an integral part of Rotary. Seen here, outside the old Hearthstone Restaurant at Scott Avenue and Green Bay Road, are a group of Rotarians at their weekly luncheon in November 1944. They included Robert Everly, Robert Johnson, Henry C. Wienecke, and Dr. Welton Richburg (not identified specifically).

This is a scene along Vernon Avenue during World War II. The children are signing up for the Clean Plate Club, designed to get children to finish all their food at meals. They were encouraged to leave nothing on their plates, as there were children around the world who did not have enough to eat. The old Village Hall is in the background on the upper right, where the parking lot is now located.

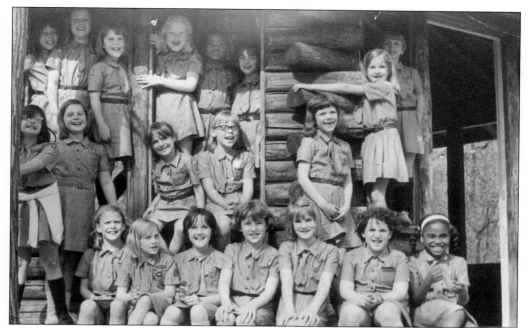

In 1948, ground was broken for the building of Little House on three acres of Forest Preserve land west of Skokie Country Club. The cabin was built to provide training in the out-of-doors for Glencoe Girl Scouts. Over the years, Little House has been the scene of many activities, including campouts, summer day camps, birthday parties, square dances, and picnics by Scouts and the Glencoe community.

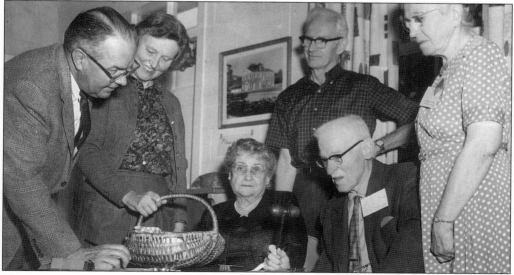

The Glencoe Historical Society was organized to preserve and promote Glencoe's past. At this old-timers meeting in 1966, 50-year residents of Glencoe gather around President Fred Holmes in the Watts Fieldhouse. Pictured, from left to right, are as follows: Mr. and Mrs. William Preston, Mrs. James K. Calhoun and her son Don Calhoun of Evanston, Mr. Holmes, and Mrs. Charles A. Saxby.

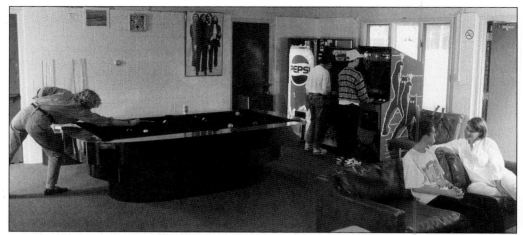

Glencoe Youth Services has been serving the teen population of Glencoe for thirty years. It is housed in Holmes Shelter, a converted ice rink warming house named for Fred Holmes, adjacent to Central School. The GYS provides community events, social service projects, recreational activities, and informal counseling services. The youth center offers games, movies, TV, and a pool table, but most of all a place to gather with friends. (Courtesy of Glencoe Youth Services.)

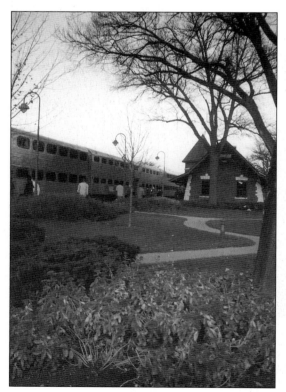

Since 1991, the Glencoe Garden Club and the Village Gardeners of Glencoe have maintained the garden at the train station with the support of the Village. Window boxes are filled with seasonal flowers and foliage to brighten travelers' days.

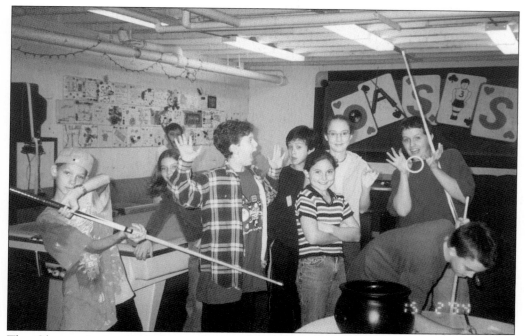

The Glencoe Junior High Project has given middle school students in Glencoe a host of opportunities for socializing, community service, and theater involvement for almost thirty years. Headquartered in the Oasis center at Central School, the youth directors and active board oversee many activities, such as school dances, the annual musical, and COVE, which offers students a chance to volunteer in the community. (Courtesy of Glencoe Junior High Project.)

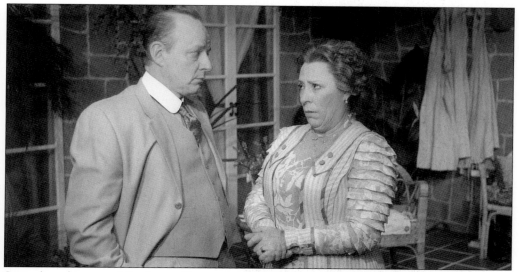

Started at the rear of Books on Vernon in 1992, Writers' Theater has been generating rave reviews and national acclaim for its professional theatrical productions. Artistic Director Michael Halberstam and associate Marilyn Campbell founded the theater focusing on "artist and the word." Above, actors Jonathan Weir and Susan Osborn-Mott appear in the 2002 production of George Bernard Shaw's "Misalliance." (Courtesy of Writers' Theater.)

Created in 1962, Friends of the Glencoe Library was formed to encourage community support for the Glencoe Public Library and to enhance the library's services. The group holds two book sales per year and uses the proceeds to fulfill special needs of the library. It also sponsors classical music concerts at the library. Shown above, a volunteer shelves books in preparation for the regularly scheduled used book sales. (Courtesy of Friends of the Library.)

The Glencoe Parent Teacher Association was formed in 1923, and throughout its history has served to strengthen understanding between parents and school staff and to aid in school activities. The Cultural Arts Committee provides the schools with programs in dance, theater, architecture, and other fine arts. Above, third graders participate in an architectural scavenger hunt at a locally landmarked home. (Courtesy of the Glencoe PTA.)

Seven

CELEBRATIONS

GLENCOE LOVES TO HAVE FUN

From its earliest days, Glencoe residents have celebrated the Fourth of July together. One of the earliest documents on record is an invitation from the Attic Club to an event on July 5, 1875 (the Fourth was a Sunday) at Newhall's Grove, north of Central Avenue (Beach Road) near the Lake Shore. The celebration, a "programme" (sic) of singing, prayer, and a reading of the Declaration of Independence, was to be followed by a pic-nic (sic). In the 1900s and 1910s, the patriotic celebration sponsorship shifted to the Men's Club and the location moved to Lakefront Park. Today, the events are sponsored by the independent, non-profit Patriotic Days Committee and the day has lengthened to include games and competitive contests early in the day, the art fair on the Village's Wyman Green (named for former Village President Austin Wyman) all day, the mid-day parade from Central School, and fireworks at the beachfront at dusk. But the spirit remains the same.

Glencoe has commemorated the death of its soldiers beginning after the First World War. Decoration Day, as it was called then, has changed a bit over the years; the name changed to Memorial Day following the Second World War, and casualties from the Korean War were added to the annual readings of the names of the honored dead. (No Glencoe soldier died in subsequent wars.) The event is a semi-subdued one, with a mix of a boisterous parade of Boy and Girl Scouts and the Central School Band with the solemn wreath laying. Today, the parade ends at the Veterans' Memorial, the mid-1990s product of an Eagle Boy Scout project by resident Kevin Maguire.

Other annual traditions have developed leading to celebrations: fall's Pumpkin Day, spring's Easter Egg Hunt, and summer's Sidewalk Sale. And Village residents have turned out for single-occasion events: the reconstruction of the Frank Lloyd Wright Bridge, the Reid Lewis-LaSalle II Expedition, and the opening of the Green Bay Trail. As recently as February 2002, residents gathered to watch the Olympic torch go by. Celebrations were often large parties: the nation's Bicentennial and the Village's 100th (1969) and 125th (1994) birthdays. Some traditions are no longer: a Memorial Day ox-roast, or dressing in costume for the Fourth of July. But, from the earliest days to today, Village residents enjoy gathering together to share the joy and sadness of life.

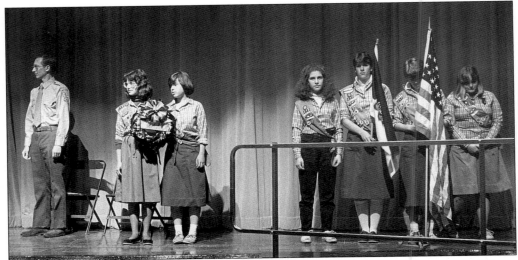

In 1983, the weather necessitated an indoor Memorial Day remembrance at Misner Auditorium. Pictured onstage, from left to right, are as follows: Bob Strong, Boy Scout Troop 23 leader; Rebecca Shubart; Katie Glicksberg; Alissa Fields; Ann Baker; Cathy Heise; and Karen Samuelson of Girl Scout Troop 212.

In spring 1973, the Glencoe Park-Recreation District Baton Corps marched in the Memorial Day parade. The Glencoe Park District had changed its name to the hyphenated version in 1965, choosing to show the two roles of a modern park district. Today, since "recreation" encompasses both "passive" recreation, (parks,) and "active" recreation, (ball fields, tennis and day camps,) the name of Glencoe Park District has returned.

The Memorial Day Ox Roast was a tradition during the 1950s and '60s. Here, Larry Sinclair, a resident known for his volunteerism, turns the spit over the open fire. The date was 1967, the location, the park along inner Green Bay Road, now known as Kalk Park.

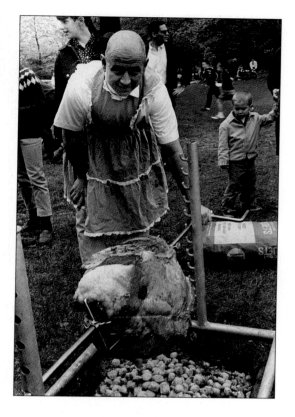

Pleasant weather and the Memorial Day parade of 1977 brought a young contingent to the curbside in the business district. Pictured, from left to right, are Alyce Baumann, Cara Conway, John Matthews, Michael Conway, and Jeffrey Shubart.

The Fourth of July has been a favorite holiday for Glencoe residents since before the turn of the 20th century. In 1916, Arthur and his sister Evelyn Wienecke celebrated with flags and costumes.

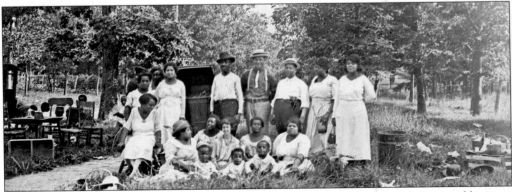

This is believed to be a Fourth of July picnic held in the 1920s in a local park. Pictured here are a number of families enjoying baskets of lunch and dinner. Third from the right in the back row is William Rankin; the others are unidentified. (Courtesy of Village of Glencoe.)

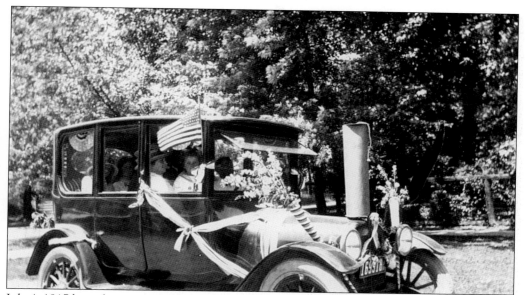

July 4, 1917 brought out a crowd in this decorated automobile. A handwritten note on the back of the photo reads: "Do you remember our all working on this?" Those inside the car are unidentifiable, but the child in the front seat in the sailor suit appears to be sitting on an adult's lap—there were no seat belts laws in those days.

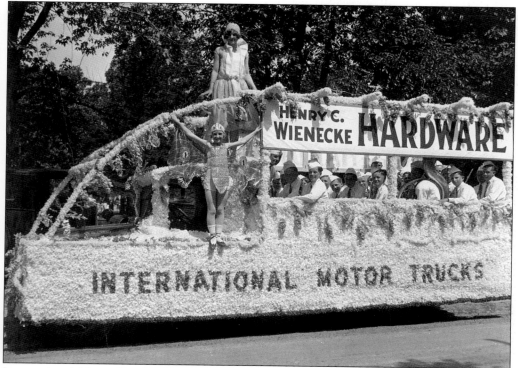

International Motor Trucks sponsored the Henry C. Wienecke Hardware float, with its band and bathing beauties, for a Fourth of July celebration sometime in the 1930s.

Boy Scouts cheered on by mothers and friends marched in this 1940s parade along Vernon Avenue, behind a 1939–40 era police car. The Mobile Oil Station at the back was razed twenty years later to make way for the 666 Vernon Plaza.

July 4, 1997 found the membership of the Patriotic Days Committee—from left, Stanton Schuman, Superintendent of (District 35) Schools Philip Price, and Patrick O'Rourke, holding his son—making presentations to parade winners. Schuman has led the Patriotic Days committee, a non-governmental, non-profit organization that organizes the Memorial Day and Fourth of July celebrations, for more than four decades. The committee solicits community donations to support both events.

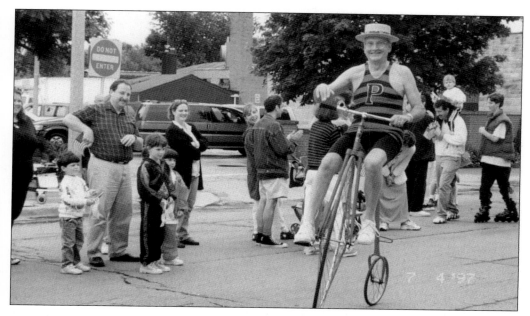

Few important Village celebrations between 1965 and the present saw a parade without Park Board President and later Village President Roland Calhoun, riding his unique bicycle. The only son of a Village President (James K. Calhoun) also to be a Village President, Roland Calhoun led the Fourth of July Parade in 1997 in his traditional 1890s costume. Below, celebrating the Village's 1969 Centennial, he led the way along the Green Bay Trail. In 1965, the Committee for the Green Bay Trail, working in cooperation with the Villages of Glencoe, Winnetka, Wilmette, and Kenilworth, created the trail on the abandoned right-of-way of the North Shore Line electric railroad. The hiking and biking trail extends north to Highland Park and south to Wilmette.

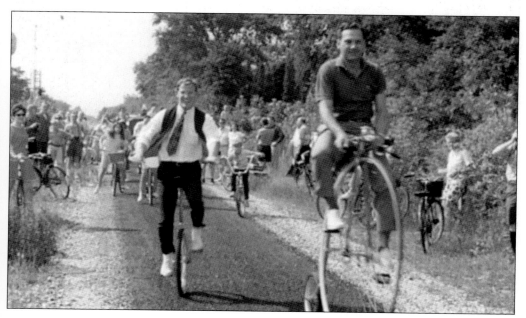

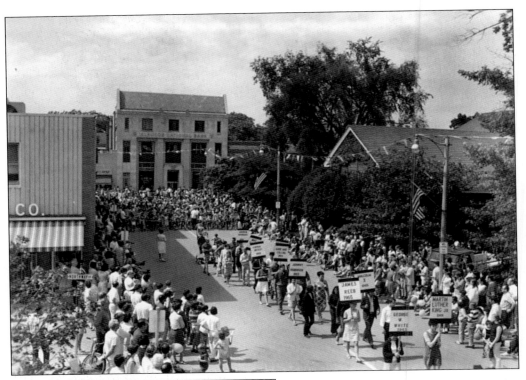

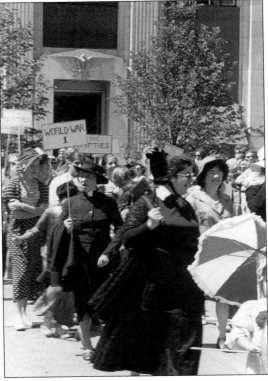

Village residents turned out in style and numbers for the celebration of the Village's Centennial birthday in 1969. This aerial view looks back to the then-Glencoe National Bank, now Harris Bank-Glencoe/Northbrook. To the left is The Fell Co., men's and boys apparel, and to the right, the Glencoe Public Library.

Glencoe's League of Women Voters marched past the Glencoe National Bank in 1976, celebrating the U.S. Bicentennial and women's roles through the eras. The National League evolved from the National Suffrage Movement. The Glencoe League was organized in 1941, with the encouragement of Winnetka's Mrs. Walter Fischer and Glencoe's Mrs. Andrew MacLeish. Women portraying eras include, from left: "World War I," Helena Seaburg, wearing her own Army nurse's uniform from the period; and "Lizzie Borden," center, Margaret Silberman.

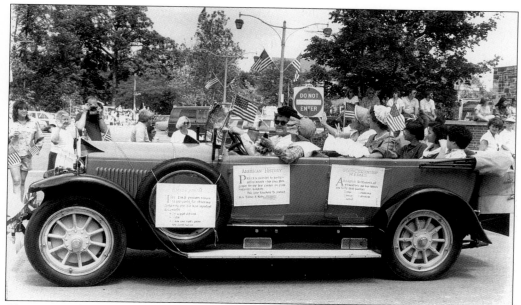

Glencoe resident Sidney Wells' antique car was driven by his son-in-law during the 1969 Centennial celebration. The decorated car celebrated the Daughters of the American Revolution, whose Glencoe chapter began in Glencoe in April 1927. Mrs. Ruth Ann Wells was a longtime member. From 1927 through 1958, the DAR sponsored the Village's Memorial Day Services. The group still is in charge of the wreath-laying ceremony on that day. For many years, the DAR Glencoe Chapter also decorated the Village Hall Speakers' Balcony and the downtown streetlights with banners.

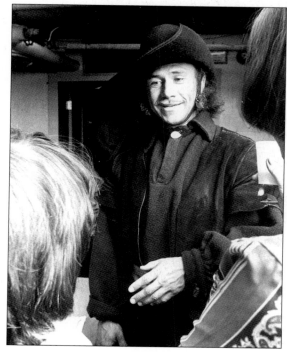

In 1979, Reid Lewis, right, and his band of "voyageurs" recreated the LaSalle Expedition down Lake Michigan through Illinois to the Mississippi River. Village residents turned out for a dinner at Central School, followed by stories and singing. Because of bad weather, the travelers could not come to the beach on canoes as planned; they arrived by bus. Village President Florence Boone greeted them dressed as a Native American.

Between 1968 and 1976, the Village Christmas tree went up in the middle of the street at Park and Vernon Avenues. By the 1980s, the tree had been moved to the northwest corner. During the 1970s, the holiday lights were strung along the building rooflines. The parking meters stand vigilant. (Courtesy of Village of Glencoe.)

The holiday tree on the northwest corner of Park and Vernon Avenues was strung with colored lights. But when Village President James O. Webb pulled the Great Holiday Light Switch, he illuminated Italian white lights that were strung in trees along both sides of the streets in the late 1990s. Children from the Village join him for the event that takes place annually at dusk on the Friday after Thanksgiving.

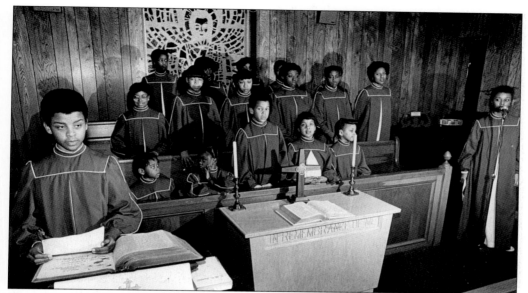

The Village annually celebrates Martin Luther King Day, with events ranging from church services to lectures and gatherings. In 1983, the event was held at St. Paul's A.M.E. Church. Pictured above are children rehearsing for the event.

The Glencoe Human Relations Committee initiated Pumpkin Day, but the Glencoe Park District sponsors it today. Children come for the same reasons they did in 1971—Halloween pumpkins, taffy apples, and balloons. The GHRC was founded in 1960. It was responsible for bringing the importance of human relations problems to the attention of the Village and served as a watchdog in matters of discrimination in housing, employment, and other areas where residents might be deprived of equal opportunities.

The rededication of Frank Lloyd Wright's Sylvan Road Bridge was an event to celebrate on October 27, 1985. Leading the short parade over the recently reconstructed concrete bridge—one of two freestanding bridges Wright ever designed—was Village President Elizabeth Warren, driving, and behind her, Village Manager David Cole. Other passengers are unidentified. The Village pitched in funds, as did the state and the federal government, but the momentum for the reconstruction came from the citizenry that contributed for the work.

Halloween brings out goblins and ghosts, pumpkins and cowboys. This group was caught walking along Vernon Avenue in the 1990s, their moms keeping a close eye on them. The Glencoe Chamber of Commerce annually sponsors an afternoon Halloween walk for children.

92

Eight
RELIGIOUS
INSTITUTIONS
STRENGTH IN DIVERSITY

For a community of less than 9,000 people, Glencoe has a diverse array of houses of worship. Catholic, Protestant—including African-American and Asian congregations—Jewish temples, and the Baha'i are all represented in Glencoe. At Thanksgiving, the congregations join together in an interdenominational community service. The annual Martin Luther King Day commemoration is a community-wide endeavor. Through community umbrella organizations such as the informal clergy association and the Interfaith Housing Center of the Northern Suburbs, individuals from the region's communities interact. Most recently, the Glencoe faith-based community banded together to raise the funds to build a Habitat for Humanity home in Waukegan, Illinois. All the congregations are engaged in addressing the needs and concerns of the local community, as well as that of the Chicago area and beyond.

The first establishment of a religious institution in the Glencoe area was a log mission church built by Jesuits more than 200 years ago. The church was located west of Roger Williams Avenue in today's neighboring town of Highland Park. The mission stood on a hill overlooking the Green Bay Trail and the Skokie Valley. The Jesuit priests ministered to the Native Americans who remained in the vicinity until 1833. The log building stood until it was blown down in the early 1890s.

The Trinity Evangelical Lutheran Church, first located on County Line (Lake Cook) Road, is one of the oldest congregations in Glencoe and traces its roots back to 1847. The church served the thriving German community that was moving to the area in concert with the tremendous surge in German immigration to the United States in the 1840s. Religious services by other early settlers were held as early as 1852 in the south part of what is now Glencoe, then Taylorsport. Services took place in the home of L.D. Taylor, a son of Taylorsport founder Anson Taylor, and in the log school house on Green Bay Road. When Dr. Alexander Hammond formed the Glencoe Company in 1869, part of the agreement of the ten investors was to pay for the construction costs of a church and $100 per year for a pastor. A site on Park Avenue was set aside and a wooden frame structure erected at a cost of $3,500 for "public worship services with no restriction as to denominational name or creed." This Congregational Church later became the Glencoe Union Church. Other churches and temples were established in the ensuing years and have contributed much to the life of the Village.

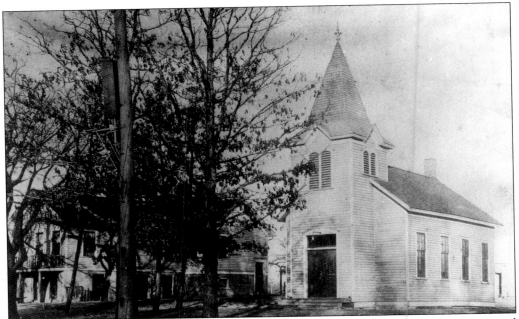

Trinity Evangelical Lutheran Church is Glencoe's oldest congregation and Cook County's second oldest Lutheran church. Early German settlers founded the congregation in 1847. The first two pastors for the church commuted from Chicago by oxcart to attend monthly services held in pioneers' homes. In 1867, this church was built at County Line (Lake Cook) and Green Bay Roads.

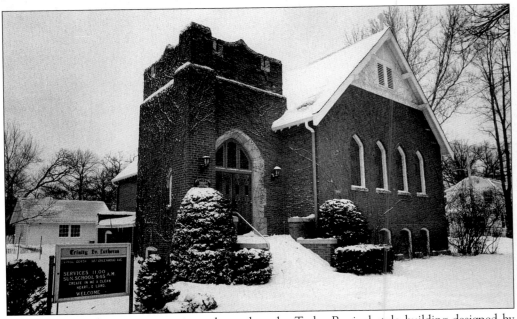

In 1921, the Lutheran congregation relocated to the Tudor Revival style building designed by architect William Spencer Crosby at Hawthorn and Greenwood Avenues. The building was extensively remodeled in 1959. Alternative German language services were held regularly at the church until the 1980s, reflecting the church's beginning as a place of worship for German families.

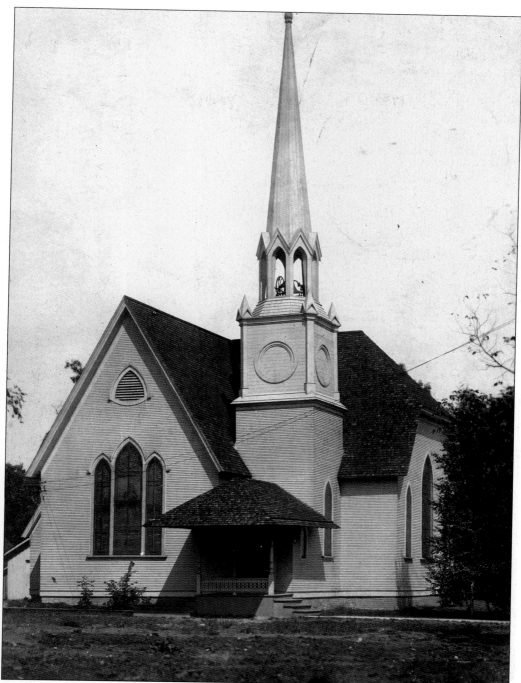

Another of Glencoe's first churches is above, the Glencoe Congregational Church, predecessor to today's Union Church. This structure was the community church created by the Glencoe founders and built shortly after Glencoe was incorporated in 1869. One of the agreements of the Glencoe Company founders was to contribute annually for a church and a pastor. The site on Park Avenue near the train station was selected, and in 1872 the church was organized.

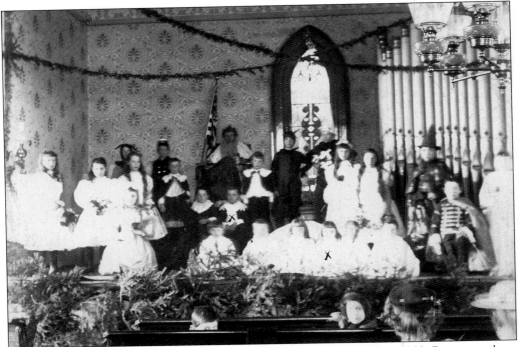

Pictured above is the interior of the original Congregational Church in 1888. Because at least four of the children at the front of the church are in costume, this may have been a pageant.

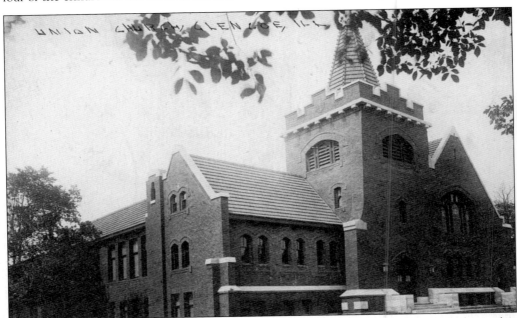

The present Glencoe Union Church was erected in 1910 after fire destroyed the earlier structure. Aligned for a time with the Congregational movement, the church became a Protestant non-denominational community church in 1911. Dr. Douglas Cornell served the church at that time and continued to do so for 34 years.

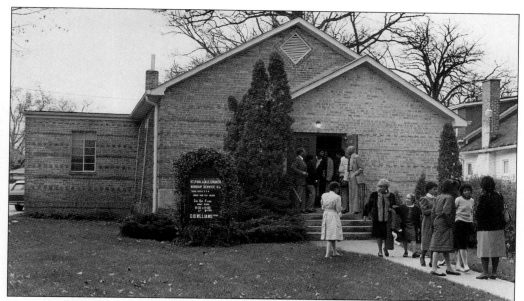

Located at 336 Washington Avenue, the St. Paul African Methodist Episcopal Church is one of Glencoe's first churches. The first services were held in 1884 at the Homer Wilson home, at 425 Adams Avenue. In 1886, the church built the first of its three buildings to meet the growing demand for services by Glencoe's African-American families. The first building was destroyed by fire in 1930. The second building, above in 1984, was erected in 1931.

The most recent building of St. Paul A.M.E. Church was designed by architect Robert Andrews and built in 1992. The annual Martin Luther King Day service and celebration held at the church is a Village tradition.

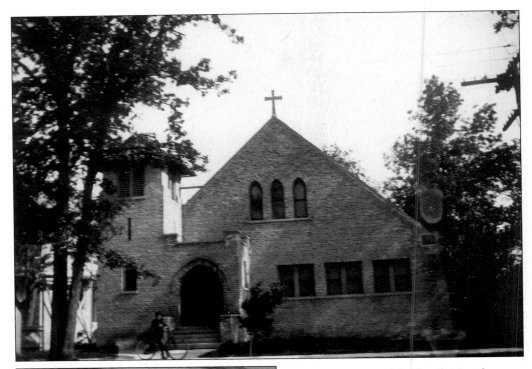

In 1897, Reverend Frederick Haarth was appointed to organize a parish for Catholics of Glencoe, Lakeside (Hubbard Woods), and Winnetka. Pictured above is the first Sacred Heart church building erected in 1897 at Tower Road and Burr Avenue, Hubbard Woods.

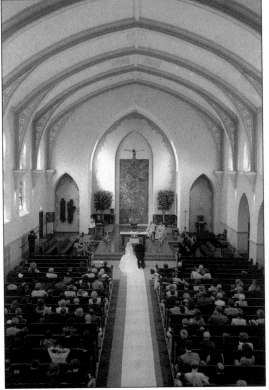

In 1926, the present Gothic style church, shown at left, was built for Sacred Heart parish. Father Haarth, the original priest, served the parish for nearly 50 years. The school, opened in 1902, is celebrating its 100th year. In 1952, a new school building was built on Gage Street, Hubbard Woods.

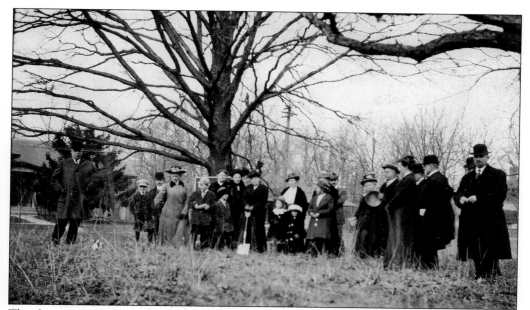

The first services of the North Shore United Methodist church were held in 1909 at 654 Greenleaf, in what was the Woman's Library Club. By 1913, the young congregation needed larger facilities, and William A. Fox provided the lot across the street at the northeast corner of Hazel and Greenleaf Avenues for a church building. Above is the ground breaking ceremony for the new church. (Courtesy of North Shore United Methodist Church.)

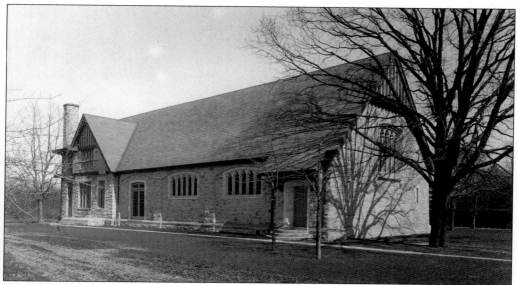

The North Shore United Methodist Church sanctuary building was dedicated in 1915. Designed by the Chicago architecture firm of Riddle and Riddle, the church is a characteristic Tudor style with stone walls, half-timbering, leaded windows, and a bell tower. Additions to the church building took place in 1948 and in the early 1960s. Hakafa Congregation, a Jewish Reform congregation, shares space within the church. (Courtesy of North Shore United Methodist Church.)

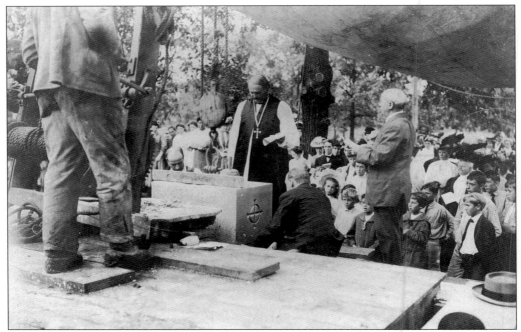

Since 1894, the Church of St. Elisabeth has been a part of Glencoe. Today it stands at Vernon and South Avenues, but the first services were held in the council chamber of the old Village Hall and then in a Park Avenue storefront. An original frame church was built in 1897 on Greenleaf Avenue and was later moved to the present site. In 1907, the church sanctuary was erected. Pictured above is the laying of the cornerstone for the church.

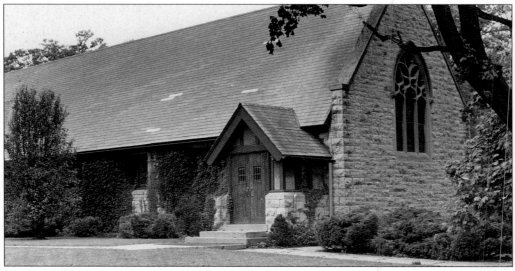

The rough limestone Church of St. Elisabeth building is a Tudor Revival structure designed by Chicago architect John Sutcliffe who was known for his church designs. The building was a gift from one of the church's rectors, Very Reverend Luther Pardee, given in memory of his mother Elisabeth Pardee. Originally known as St. Paul's Mission, the church was consecrated in 1907 and the name changed to Saint Elisabeth's.

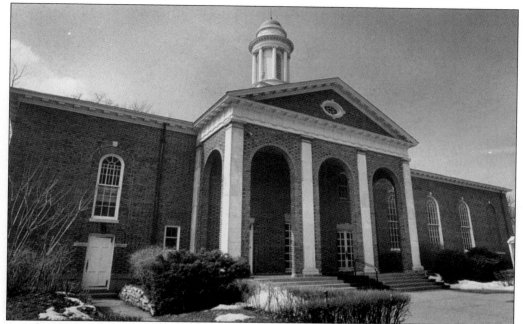

The First Church of Christ, Scientist of Glencoe was organized in February 1921 by residents of Glencoe who were formerly members of a Highland Park Christian Science Church. Services were held in the Masonic Hall in Glencoe until the new church was built at the corner of Greenleaf Avenue and Beach Road in January of 1928. The church is Neoclassical in design, built of red brick with white marble trim and a slate roof.

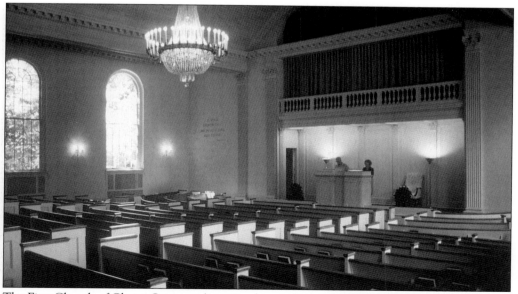

The First Church of Christ, Scientist (interior shown above) was designed by Glencoe architect Leon Stanhope, who also designed the Glencoe National Bank (Harris Bank Glencoe/ Northbrook) on Park Avenue. Today the church is home to the Korean Carmel Presbyterian church. (Scott Javore photo.)

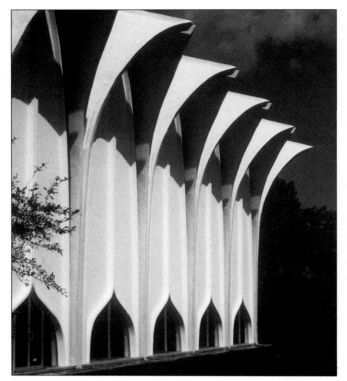

Founded in 1920, North Shore Congregation Israel was the first Reform Jewish congregation on the North Shore. In 1928, its first house of worship was dedicated at Vernon and Lincoln Avenues where Am Shalom congregation now worships. In 1964, the congregation commissioned architect Minoru Yamasaki to design this national award-winning curvilinear modern house of worship on the former Lady Esther estate on Lake Michigan. (Scott Javore photo.)

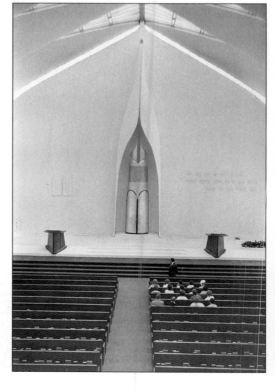

The interior of North Shore Congregation Israel expresses a theme of "light." This photograph, taken in 1967, shows the soaring roof, 55 feet high with amber skylights. The temple has a full array of educational, cultural, and social action programs for the community.

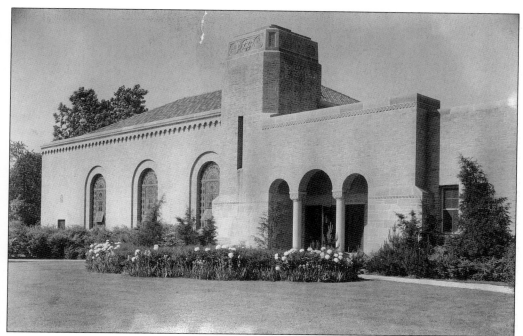

Am Shalom is a Reform Jewish congregation founded in 1972. Hosted at other locations, the congregation purchased the former North Shore Congregation Israel temple on Vernon Avenue in 1982 from the Willow Academy for Girls, which had been in the building for about a decade. The older wing of the building was designed in 1926 by Alfred S. Alschuler Sr., president of the temple at the time and noted religious institution architect.

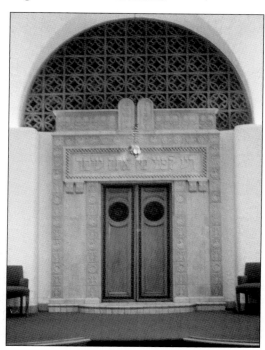

The sanctuary of the temple is reminiscent of the Spanish Revival style of the building. Am Shalom is an active temple with many social action programs, a large religious education school, and a nursery school.

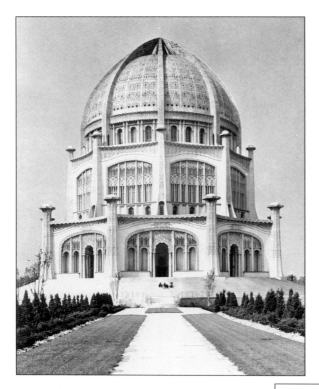

The Glencoe Baha'i community is part of the worldwide religion founded in 1863. In 1964, the Local Spiritual Assembly of Glencoe was formed. It is related to the Baha'i House of Worship, seen here, located in neighboring Wilmette and a well-known regional landmark. Glencoe Baha'is have contributed to the life of the community in keeping with the Baha'i principle of serving mankind.

For many years, all Glencoe religious congregations have gathered together at Thanksgiving time to worship and give thanks. The service rotates to a different sanctuary each year. This notice for the annual service predates 1947, the year the Glencoe Relief and Aid Society was renamed Family Counseling Service of Glencoe.

Community Thanksgiving Day Service for Glencoe

(ALL THE CHURCHES UNITING)

will be held in the

Episcopal Church

Vernon and South Aves.

at 11 o'clock in the morning of

Thanksgiving Day

Offering will be for
Glencoe Relief and Aid Society

Nine

TRANSPORTATION

ALONG THE TRAILS AND RAILS

Originally travelers' feet provided access to and from Glencoe on the footpath along Lake Michigan. In 1832, Congress authorized the Green Bay Trail as a four-horse stage route; Glencoe's first white settler Anson Taylor, who arrived in 1835, built his LaPier Inn as a stage coach stopping point along the way. The trail was heavily trafficked, as was the water route to Chicago, with two steamboats making the way regularly: the John Lillie and the Garter.

But Glencoe's greatest transportation boost came with the railroads. The first train ran from Chicago to Waukegan in January 1855, a three-hour run. Commuting fathers looked to escape the political corruption, labor unrest, and the soot and dirt of the industrial city, leaving their families settled in bucolic Glencoe while they toiled in the city. Walter Gurnee, president of the Chicago and Milwaukee Railroad, the railroad that made the first runs, selected the Glencoe train stop and gave the village its name. Michael Schinler was the first station agent. His wife ran out to flag the train, which originally stopped only on signal.

In the 1860s, Gurnee's line was bought by the Chicago and Northwestern Railroad, which operated until the mid-1990s, when the Union Pacific took control. In 1891, the railroad replaced the existing shack with the building that is a Village landmark—a brick station designed by a Chicago architect, Charles Frost, in the Richardson Romanesque style.

Between 1899 and the mid-1950s, the Chicago North Shore and Milwaukee Road, America's fastest interurban electric line, also ran through Glencoe. The North Shore had eight stops in Glencoe: Green Bay and Maple Hill Road, Lincoln, Park, Hazel, Hawthorn, South, Harbor, and Woodlawn. Frank Lloyd Wright designed the station at Green Bay and Maple Hill; it has since been demolished. Part of the discontinued line's right-of-way today is incorporated in the Green Bay Trail.

As the town grew, dirt roads filled with wagons and carriages. Then came the automobile. Glencoe residents, fearful of high speeders—those at 25 miles an hour—put raised bricks at each crossing on Sheridan Road (the famous "Glencoe bumps") to slow down the "scorchers."

In 1964, the Edens Expressway was developed for faster travel, named in honor of Col. William G. Edens, a pioneer paved-road advocate. The road was planned as a main artery to attract the growing volume of cars and trucks away from the residential areas. Originally, it was to have been a four-lane parkway with trees down the middle.

Sheridan Road began as an Indian trail. It later became the first paved link to Milwaukee, and was named in 1886 in honor of Civil War Gen. Philip Sheridan. In 1888, Fort Sheridan was built north of Highland Park in response to Chicagoans' demand for troops nearby. They feared more labor trouble such as the 1887 Haymarket Riot that General Sheridan had suppressed. With the building of the fort came the construction of a pleasurable drive that followed the Lake Michigan shore, and with the reversal of the Chicago River and the lack of sewage dumped in the lake, more lakeshore mansions were built facing the lake rather than the road.

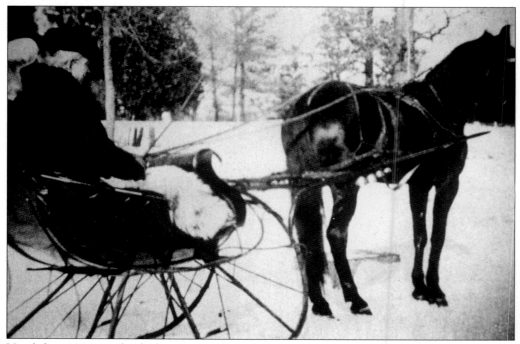

Until the 1920s, much of Glencoe travel was done on horseback, by carriage, or, in the winter, by horse and sleigh. Above is a cutter sleigh drawn by a horse named Patsy. Helen Calhoun Woolson, born in 1892, is the rider.

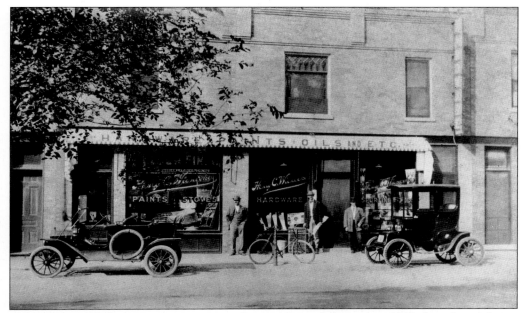

Shoppers used different means to get to the commercial district in 1910: bicycles and cars worked as well as walking. This scene is at the front of Henry C. Wienecke's Hardware Store, where paints, stoves, and sporting goods were sold in addition to hardware items.

Children traveled the sidewalks of Glencoe via various modes of transportation. Here, from left, Helen, 10 years old, and her younger brothers, Donald and Everts Calhoun, show off a two-wheeled bicycle and a wagon pulled by a four-wheeler. The photo dates to *c.* 1905.

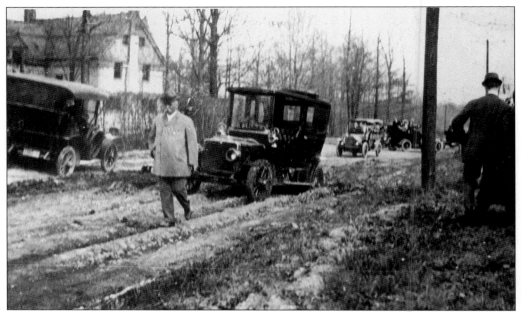

To become stuck in the mud along a village street was not unusual until early in the twentieth century. The first street grading was done in 1872, but only between the railroad and Bluff Street along Park Avenue. Later, other streets were improved; ditches were dug beside the dirt roads for drainage. In 1886, gravelling of Vernon Avenue from Park to South Avenues began. It took two years to cover the entire village. In 1891, macadamizing began. Brick pavements did not arrive until 1914–15. Sheridan Road was paved with concrete in about 1925.

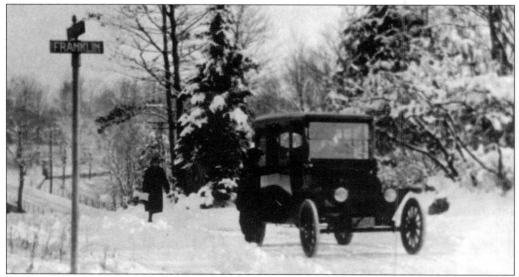

The corner of Franklin and Sheridan Roads was snowed in at an unknown date, although the car appears to be from the 1910s. Behind the car, a woman is walking, a common mode of transportation then as now. The Village's largest snowfall, one that engendered considerable comment by local historians, came in 1918. The bridge in the background, along Sheridan Road, was built in the 1880s and rebuilt in the 1920s. (Courtesy of Village of Glencoe.)

Gathering at the station to bid farewell to a visitor, were, from left: Suzy Mitchell, Patty McGowan, Malcolm Mitchell, ? Cole, Hall Barnett, Jimmy ?, and unidentified. Suzy's pinafore (colloquially called "pinnies"), Jimmy's knickers, and the sailor suit worn by the child in front were typical children's outfits of 1919, the year the photo was taken.

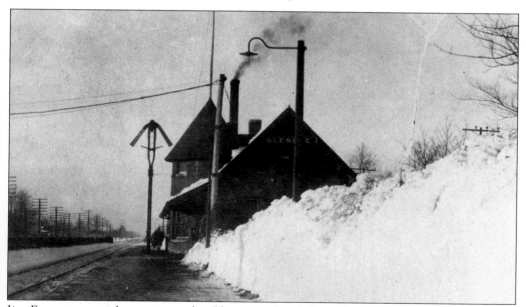

Jim Fawcett was ticket agent at the Glencoe railroad depot for many years. The semaphore signal (left of the turret) controlled the trains, the position of the arm indicating "go through," "proceed with caution," etc. The western sidetrack, far left, was used for deliveries, often lumber for the yards located south on Glencoe (Green Bay) Road. At each grade crossing in the Village, there was a shanty where an employee would put the gates down and put up the "stop" sign when trains came through. Between trains, he would garden. It is likely this undated photo was taken after the 1918 snow.

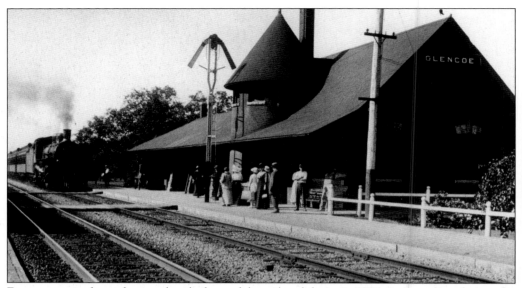

Everyone waited together on the platform of the railroad depot in 1914. In its earliest design, the station was divided into men's and women's rooms with separate entrances. At the north end of the depot was a luggage room, where the local post office brought mail to ship to Chicago and the station agent received incoming mail, trunks, suitcases, and boxes. Steam engines were common along the Chicago and North Western line through the 1950s.

Chicago Tribune cartoonist Garr Williams spoke to the region from his hometown station in Glencoe in what must have been a cold March of 1935. During and following the First World War, Williams did cartooning for the Village war efforts, when his postcard illustrations were used to gather the Glencoe Rifles together. (Book collections of his cartoons, which poke fun at everyday life, can be found in the Glencoe Historical Society Research Center.)

In 1936, Police Office Pete Kloepfler used a modern means of transportation—a motorcycle—while on patrol in front of the old Village Hall on Vernon Avenue. Behind him is a 1934 Studebaker President automobile. Today, the Village parking lot sits on the site.

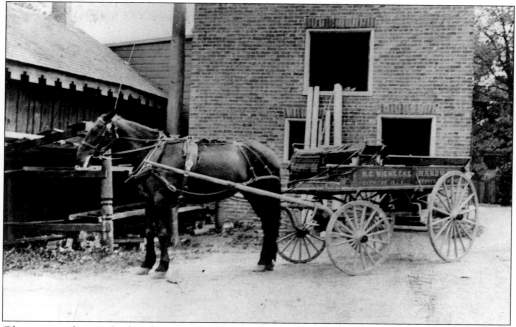

Glencoe residents relied on horse and wagon-delivered goods for many of their necessities, from food to furniture, through the 1920s and 1930s. Here, the Henry C. Wienecke Hardware wagon awaits both driver and goods to deliver. The wagon is standing behind the main store. The building behind the wagon is a warehouse/service/barn building also owned by Wienecke's. It was razed in the 1960s to make way for a parking lot.

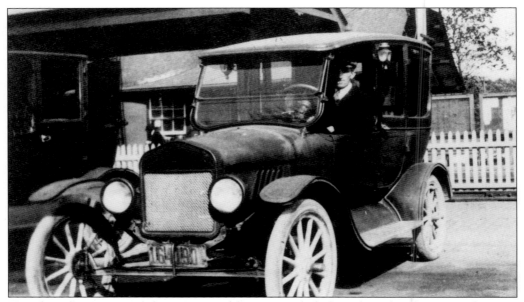

Taxis have been a means of getting to and fro—particularly from the railroad station to home—for many people since the 1930s, which is when this photo was taken. The taxi driver is Louis Diettrich, who drove cabs in town until the late 1950s.

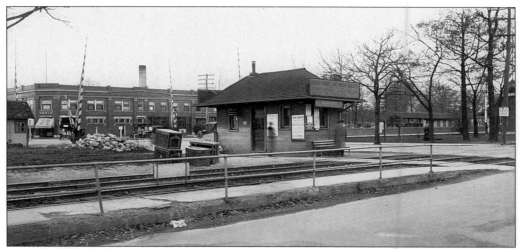

In the 1930s, suitcases were piled outside the Chicago North Shore and Milwaukee—the North Shore Electric Line—station at Park Avenue. Behind the station was the shanty where flagman Hans Kushner signaled for the Chicago and North Western. The flag house was razed in the 1940s. The North Shore Line was completed in 1908. Beginning as a modest Waukegan trolley line in the 1890s, the North Shore Electric reached its heyday in the 1920s, run by the capital and skill of utility mogul Samuel Insull. The North Shore became one of the finest electric interurbans in America, but declined after the Great Depression and never rebounded, despite the introduction of the Electroliner in 1941 on the Skokie Valley route. It ceased running in 1963, the victim of economics. After the demise, the Village bought the rights-of-way it did not already own for $50,000 and used the land to create Glencoe's portion of the Green Bay Trail. Harold G. Mason, president of the Highwood-based North Shore Line and a Glencoe resident, took this photo.

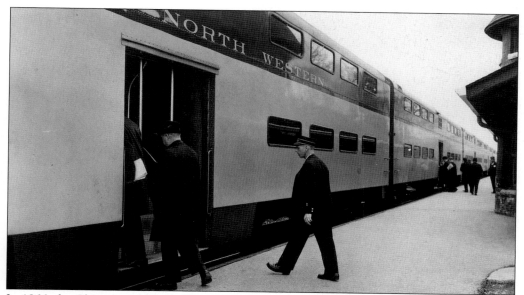

In 1866, the Chicago and North Western Railroad bought the Chicago and Milwaukee Railroad line that had been the first to come through Glencoe. The C&NW was a freight line, which added passenger service as an afterthought. By the turn of the twentieth century, the tide of business changed and the C&NW looked to its commuter lines for a significant portion of business. Railroad-produced brochures touting the North Shore wooed city residents north, promising communities equal to "paradise." A conductor follows commuters onto the double-decker coach in 1969, prior to the Village's platform upgrade in 1976. (Courtesy of Village of Glencoe.)

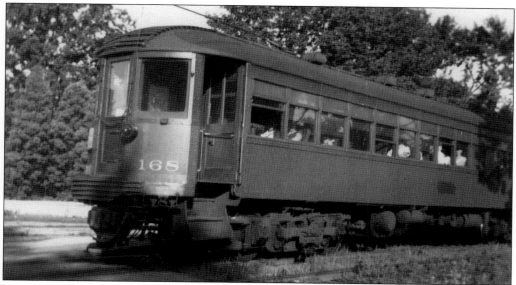

Severe speed restrictions imposed by conditions along the 23-mile Shore Line Route limited the North Shore Electric Line's capability for high terminal-to-terminal average speeds. But that did not stop many from organizing a "Save Your North Shore Line" poster campaign in the early 1960s, when the North Shore cited a ten-year operating loss in excess of $4 million and asked regulators permission to abandon operations.

A bus, presumably from the Evanston Bus Co., makes its way along Glencoe (now Green Bay) Road to Evanston's elevated train station in this undated photo. When the privately owned bus company failed, Nortran, a public utility, was formed to operate north suburban buses of various former private companies. Leonard Eisenberg was Glencoe's representative to the Nortran board. Today, after further consolidation, buses are provided by Pace, the suburban bus branch of the Regional Transportation Authority. Former Village President Florence Boone was the first chairman of Pace. (Courtesy of Village of Glencoe.)

A view from the Jackson Street side of South School in the 1950s showed how popular bicycles were particularly before Glencoe's schools were separated by ages and grades. Prior to 1978, when students attended schools grouped by neighborhood—North, South, West, and Central—they had an hour and a half for lunch, giving each one enough time to go home on their bikes, eat lunch, and return. (Courtesy of Glencoe Park District.)

Ten
ARCHITECTURE

BEAUTY, STATELINESS, AND VARIETY

Glencoe, located 18 miles north of Chicago along Lake Michigan's "North Shore," is intersected by ravines with areas of lovely homes set into the natural landscape. Glencoe also is a museum of domestic architectural styles dating from the mid-19th century. The earliest examples of Glencoe-area architecture were the farm houses and vernacular cottages that dotted the landscape during settlement in the mid-1800s. By the 1870s, however, Glencoe was developing as a suburb with stately homes of various styles, some of which were designed by architects and were illustrative of the "country" homes of city businessmen, successful entrepreneurs, and professionals who could afford large, comfortable homes. Examples of Italianate, Second Empire, Queen Anne, and Greek and Gothic Revival styles can be found within Glencoe. But many of the houses were those built by carpenters who referred to pattern books available at the time. Andrew Jackson Downing's "The Architecture of Country Houses" sold 16,000 copies by the end of the Civil War and helped to popularize a number of these styles.

Toward the close of the nineteenth century, this era, loosely called Victorian, ended and two distinct movements in architectural styles developed. The first was eclectic, or academic, and copied certain elements of past styles, especially European. The movement received tremendous impetus from Chicago's 1893 World's Colombian Exposition. European-trained architects designed landmark period houses for wealthy clients. This movement fostered historical styles such as Neoclassical and Tudor, Spanish, French, and Colonial Revivals.

The other movement was modern or progressive and did not imitate past styles. The Prairie School and Bungalow/Craftsmen styles were manifestations of the modern movement at the turn of the century. Prairie-style architecture originated in Chicago and is one of the few indigenous American styles. Frank Lloyd Wright and other Chicago architects sought to create buildings that reflected the rolling Midwest prairie terrain. Outside of Oak Park and Chicago, Glencoe contains the highest concentration of Wright-designed homes. There are numerous other Prairie structures as well as Bungalow styles in Glencoe. The Prairie movement came to an abrupt end after World War I, but Bungalows continued to be built until the 1940s.

Beginning again in the 1930s and post-World War I, modern homes were built in abundance in Glencoe, with International, post-Prairie, and split-level styles. Many homes, however, continue to be built with allusions to historical styles. In its residential, commercial, and public buildings, Glencoe retains the spirit of the ideal community conceived by Dr. Alexander Hammond 150 years ago. This is reflected in the lovely homes, abundant park land, small-scale public buildings whose designs blend with their residential surroundings, and a business district with the atmosphere of a village.

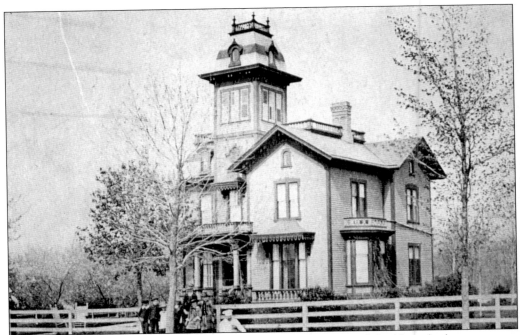

The Frederick Newhall home was built in 1871. The original building had a two-story belvedere tower, seen here. The home was nicknamed "Breezy Castle" by its residents because of the difficulty in heating it. The tower has been removed, but the home still retains the Victorian features of a mansard roof and Italianate design.

Most early houses in Glencoe were either farm houses or vernacular buildings. From about 1830 to 1850, the Greek Revival movement dominated American architecture. A typical Greek Revival home had a front-facing gable, which echoed the pedimented façade of Greek temples. This dominated vernacular or folk houses into the 20th century. The handsome vernacular home pictured above has original siding, a side bay, and front porch with a roof supported by round Doric posts. (Susan Myrick photo.)

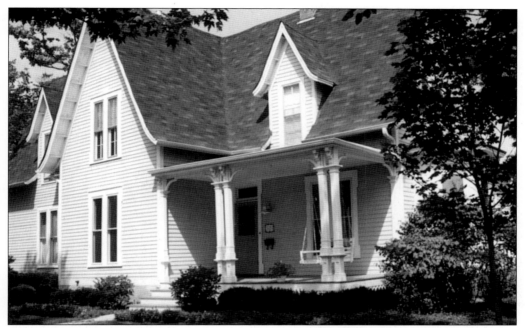

The romantic movement of the 19th century fostered an interest in architectural styles, including Gothic Revival seen in this very early Glencoe home. This house was built by Charles Browne, one of the original Glencoe Company founders. Pattern books helped to disseminate plans for these style homes. (Courtesy of Village of Glencoe.)

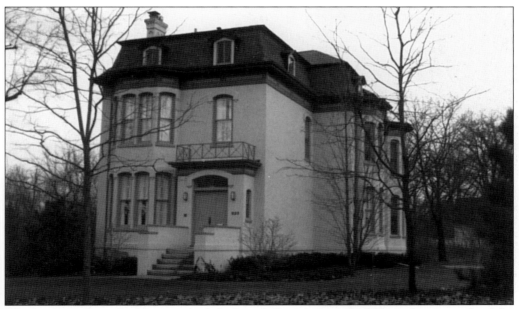

This house on Greenleaf Avenue, built by Joseph Daggitt around 1875, is a fine example of the Second Empire style of architecture that was popular after the Civil War. The main feature of this style is the mansard roof seen above. In 1838, the Daggitts settled in the area near County-Line (Lake Cook) Road, east of the Green Bay Trail. (Susan Myrick photo.)

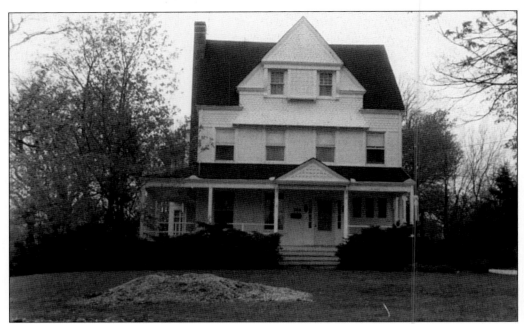

This home is an example of Queen Anne architecture with excellent detailing. This style, popular in the last decades of the 1800s, stresses a contrast of materials as well as a variety of roof and wall projections. Decorative shingles were often used, including the fish-scale and round shingles seen on this home.

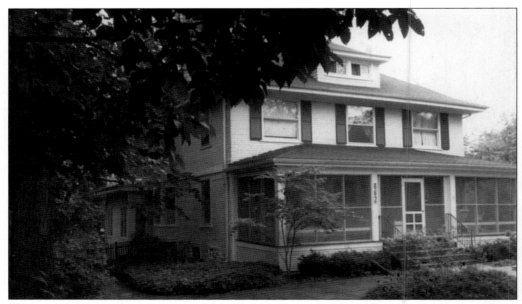

The overall shape of this house is what is known locally on the North Shore as a "Foursquare." The style developed as a reaction to the more elaborate Victorian house designs. As a result, these homes are straightforward and uncluttered in design. The Foursquare term refers to the floor plan and symmetrical window placement. These houses usually feature a broad-hipped roof with a central dormer window and a large front porch. (Susan Myrick photo.)

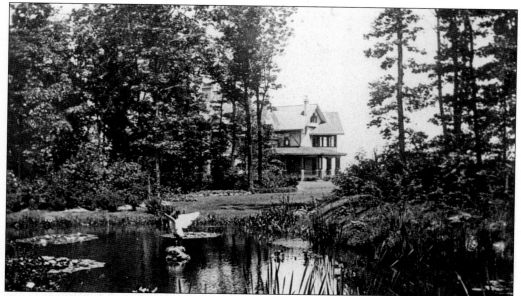

The grounds at Indianola for the Herman Paepcke estate were the early work of noted landscape designer Jens Jensen. This pond is part of the property; the house sits on the lakefront bluff in the distance. Architect for the house, Ernst Jebsen, and Jensen had been active in Humboldt Park in Chicago. Jensen advocated naturalistic design through the use of native plant groupings, gently curving forms, and concealed spaces. The house no longer stands. (Courtesy of Marianne Crosby.)

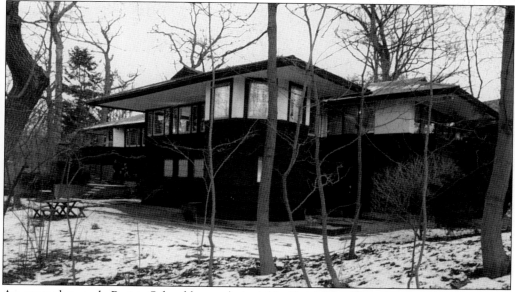

An exemplary early Prairie School house designed by Frank Lloyd Wright, the Glassner House, was built in 1905 for bicycle manufacturer William Glassner. Glassner held a competition to build a servant-free house for $5,000. Wright conceived of a horizontal house set into the brow of a hill on a deep ravine. There are broad overhanging eaves, bands of windows with art glass, and rough hewn wood siding on the ground floor.

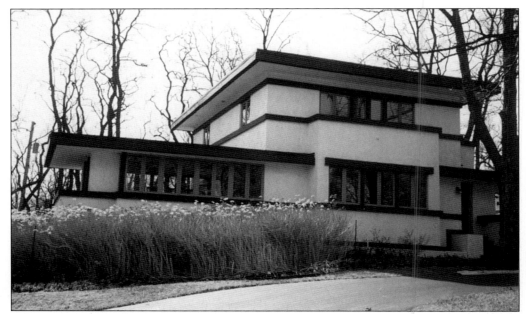

The Ravine Bluffs development in northeast Glencoe was designed by Frank Lloyd Wright between 1905 and 1915. Five of Wright's "fireproof" homes were built for $5,000 in addition to a house for Sherman Booth, who owned the property and served as Wright's attorney. Shown here is the Hollis Root house, which typifies the Prairie style with clean, simple lines, heavy wood banding, and rows of casement windows.

One entrance to the Ravine Bluffs subdivision is reached via a bridge over a deep ravine. The bridge is one of only two freestanding bridges designed by Frank Lloyd Wright. Due to severe deterioration, the bridge was faithfully reconstructed in 1985. There are also three sculptures that include planters and light posts which mark the boundaries of the subdivision.

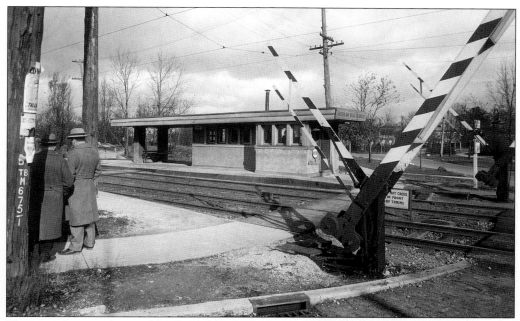

This train station, designed by Frank Lloyd Wright around 1915, was part of the overall design of the Ravine Bluffs subdivision. Razed in the 1950s, the station stood at Maple Hill Road and the railroad tracks. It was part of the electric railroad system between Chicago and the North Shore. This station echoes the houses in the subdivision with their flat, cantilevered roofs, bands of windows, and simple geometry.

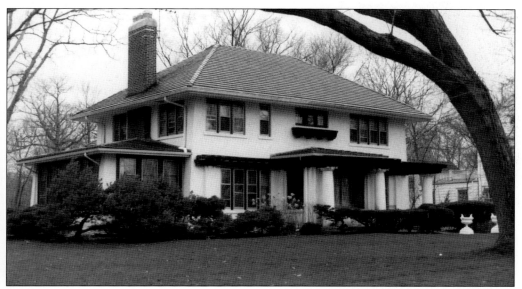

This 1915 home, attributed to architect George Maher, is a typical example of the more traditional symmetrical Prairie School house. The front door is tucked within a porch supported by massive round Doric columns. A pergola in the Arts and Crafts style is extended to the north of the porch. Maher designed many Prairie School houses on the North Shore. (Susan Myrick photo.)

"Birken Craig," was owned by Bruce MacLeish, chairman of the Carson Pirie Scott department store for many years. After World War I, fashions shifted to period styles based on European or American colonial precedents. The remodeling of an earlier 1896 structure was done for MacLeish by architect Chester Walcott in the mid-1920s in the fashionable Neoclassical style.

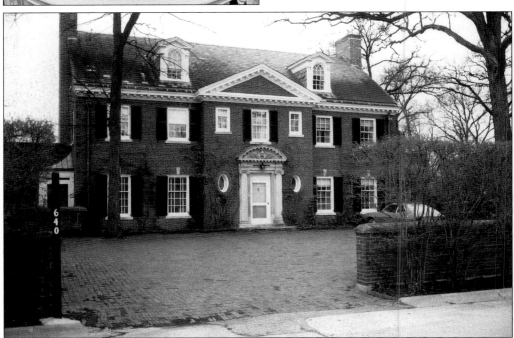

This red brick Georgian style home is a very pure example of the genre. It has an elegant design with a center entrance, surrounded by stonework that includes pilasters of Ionic columns and a rounded pediment containing an eagle design. The roof line is decorated with large-scale dental molding. The house was designed for Alfred Watt around 1928 by architect William Furst of Armstrong, Furst and Tilton. (Susan Myrick photo.)

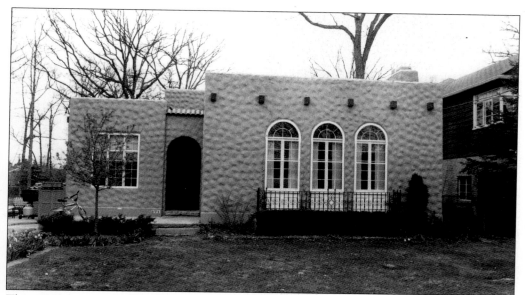

This 1927 home is a fine example of Spanish Colonial Revival style most common in the southwestern states and Florida, but also built in 1920s communities around the United States. The impetus for the style came from the Panama-California Exposition in San Diego in 1915. Typical features are the arched windows, projecting roof rafters, iron grill, and stucco walls. The architect was Jay Hunt. (Susan Myrick photo.)

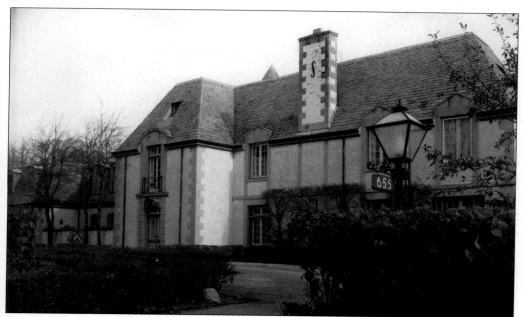

This elegant French Normandy style home was built in 1926 and designed by architects Loebl and Schlossman for Harry Misch. Typical French architectural features are the steep sloping roof, the second floor windows with pointed arches that project beyond the roofline, and the "quoins" or notched stonework on the corners of the house and chimney. The tip of a conical tower to the rear can be seen to the left of the chimney. (Susan Myrick photo.)

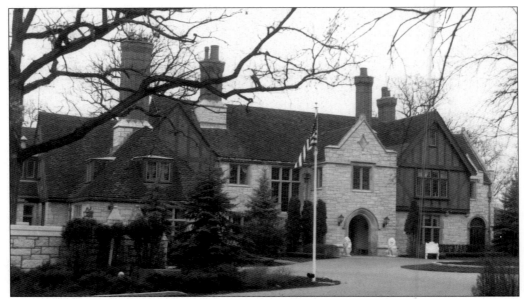

Glencoe architect Ralph Stoetzel designed this stately Tudor Revival home in 1929 for the department store owner E.F. Wieboldt. The Tudor Revival style incorporates a variety of medieval English architectural elements. This home's features include half-timbering, heraldic emblems inset in leaded windows, ornamental chimneys with pots, and steep front-facing gables. (Susan Myrick photo.)

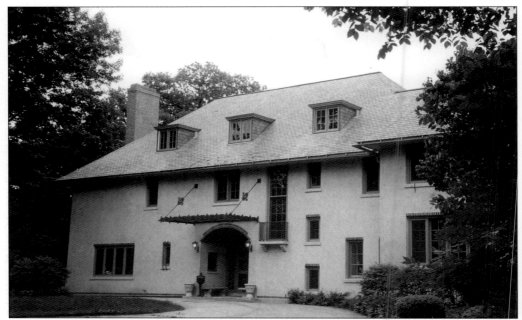

This home is one of a group of four designed by Howard Van Doren Shaw for the Born-Foreman estate in northeast Glencoe. Shaw was an American Institute of Architects Gold Medal winner. Among many well-known landmarks on the North Shore, he designed Market Square and his home, Ragdale, both in Lake Forest, and Lake Shore Country Club in Glencoe.

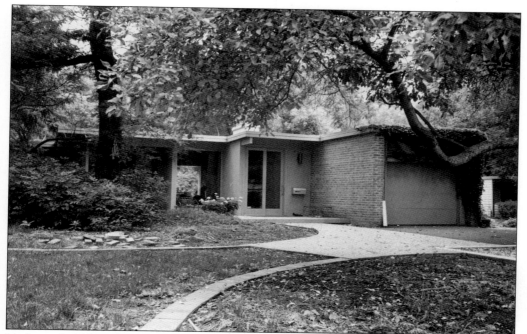

In the early 1950s, the architecture firm of Keck and Keck designed a group of contemporary, passive solar heated homes in the Forest Crest subdivision in north Glencoe. The houses feature floor-to-ceiling picture windows with louvered shutters on the sides that provide ventilation. The roofs extend over the windows to provide passive solar protection. Floors have radiant heat and roofs are flat.

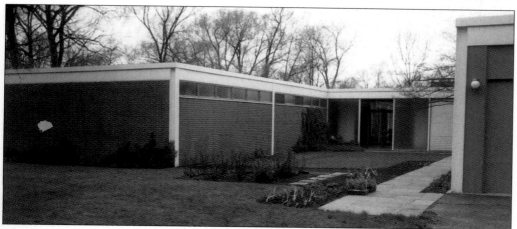

This home is a representative International Style house designed by James Speyer who studied under Mies van der Rohe at the Illinois Institute of Technology. Simplicity and precision were hallmarks of Miesian architecture. All non-essential decoration was rejected. Strips of windows and solid planes help create a horizontal feeling. (Susan Myrick photo.)

The addition to North Shore Congregation Israel, built in 1982, is a representative Postmodern style structure designed by Hammond, Beeby, and Babka, Architects. It contains a composite of a few strong geometric shapes; the main structure is a cylinder with square windows ringing the cornice line. A large circular window is set under a three-dimensional Palladian arch with Doric columns. The building houses an intimate sanctuary and a social hall. Thomas Beebee received a 1984 National Honor Award from the American Institute of Architects for his design. (Scott Javore photo.)

Selected Bibliography

Bach, Ira. *A Guide to Chicago's Historical Suburbs*. Chicago, Swallow Press, 1981.

Benjamin, Susan, ed. *An Architectural Album: Chicago's North Shore* Jr. League of Evanston, 1988.

Dickinson, Lora Townsend. *The Story of Winnetka*. Winnetka Historical Society: 1956.

Ebner, Michael. *Creating Chicago's North Shore*. University of Chicago Press: 1988.

Glencoe Chamber of Commerce 2001-2002 Community Guide.

Glencoe Historical Society *Seventy-Five Years of Glencoe History 1835–1944*.

Glencoe Historical Society. "A Link to the City and the Past," 1991.

Glencoe Historic Preservation Commission. "Glencoe Architectural Guide Map." 2nd Edition 2002.

Glencoe Historic Preservation Commission. "1998 Architectural Trolley Tour."

Glencoe Historic Preservation Commission. "2001 Architectural Trolley Tour: Glencoe's Houses of Worship."

Glencoe Historic Preservation Commission. "Washington Avenue Housewalk" 1996.

Grubb, Ann and Evey Schweig. *What's So Great About Glencoe?* Glencoe Historical Society and Glencoe Historic Preservation Commission: 1998.

Junior League of Evanston, Inc. "This Gingerbread is Not for Eating." 1986-1987.

Meldman, Suzanne Carter. "The City and the Garden: the Chicago Horticultural Society at Ninety," 1981.

Lind, Carla. *Lost Wright*. Simon & Schuster: 1996.

Thulen, Marj, ed. *Glencoe Lights 100 Candles*. Glencoe Historical Society: 1969.

Weiss, Suzanne. *Glencoe: Queen of Suburbs*. Glencoe Historical Society 1989.

"Wright Plus North in Glencoe." Frank Lloyd Wright Home and Studio, Glencoe Historical Society and Glencoe Historic Preservation Commission, 1993.

Unless otherwise indicated, all photos are from the collection of the Glencoe Historical Society.

INDEX